This book is dedicated to my mama.

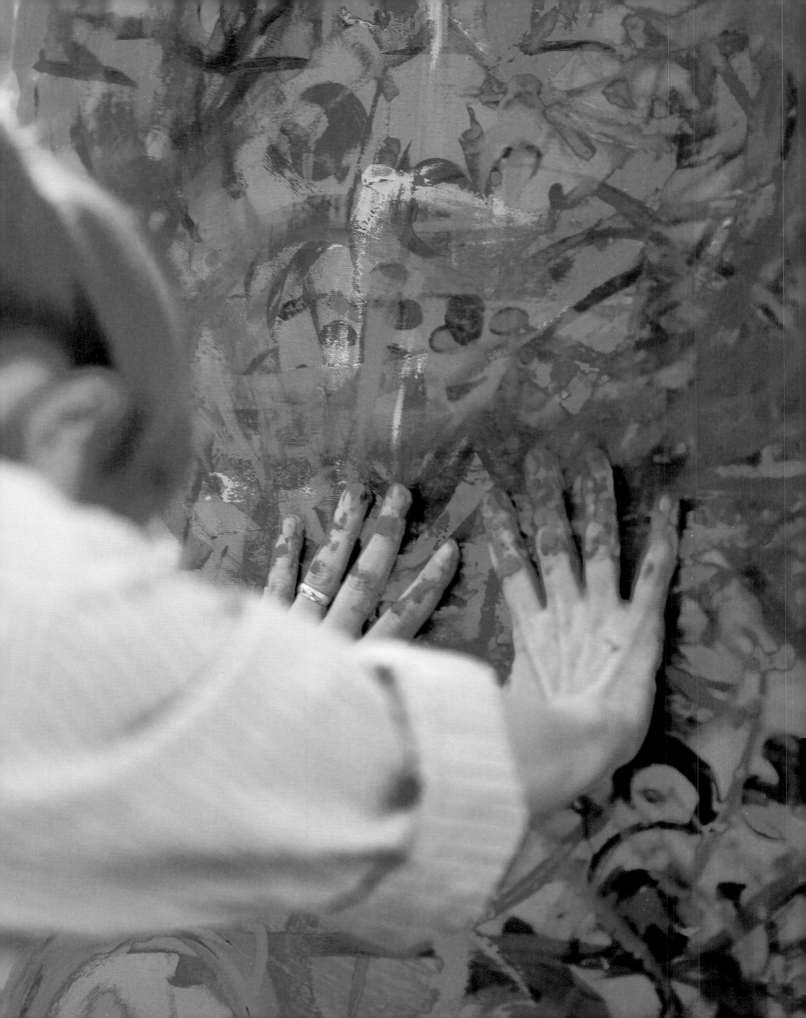

Flora Bowley

CREATIVE REVOLUTION

Personal Transformation through Brave Intuitive Painting

QUARRY

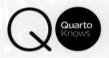

Quarto is the authority on a wide range of topics.

Quarto educates, entertains and enriches the lives of our readers—enthusiasts and lovers of hands-on living.

www.QuartoKnows.com

© 2016 Quarto Publishing Group USA Inc.
Text © 2016 Flora Bowley
Images © 2016 Zipporah Lomax

First published in the United States of America in 2016 by
Quarry Books, an imprint of
Quarto Publishing Group USA Inc.
100 Cummings Center, Suite 406-L
Beverly, Massachusetts 01915-6101
Telephone: (978) 282-9590
Fax: (978) 283-2742
QuartoKnows.com
Visit our blogs at QuartoKnows.com

10 9 8 7 6 5 4 3 2 1

ISBN: 978-1-63159-259-1

Library of Congress Cataloging-in-Publication Data available

Design and page layout: Laura Shaw Design, Inc.
Photography: Zipporah Lomax

Printed in China

Contents

Introduction

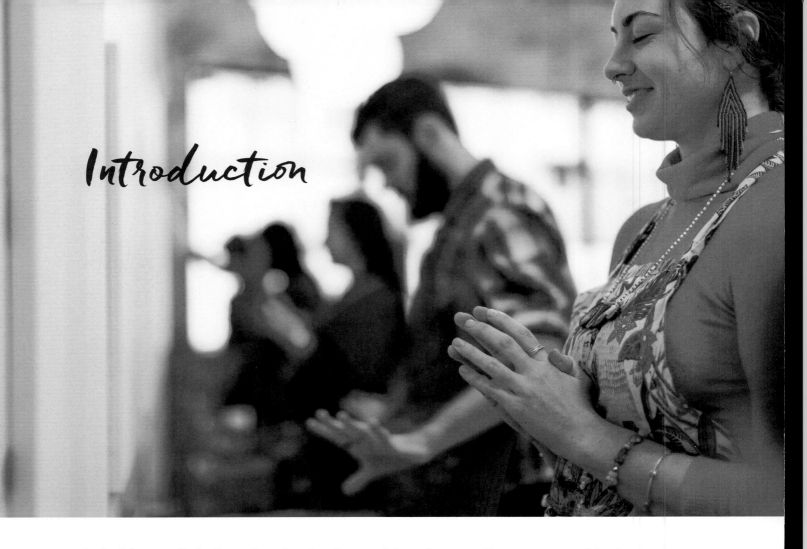

I wholeheartedly believe that the simple act of dragging your fingers across a blank canvas with enough intention and curiosity can be a powerful—*even revolutionary*—act.

The same holds true when you move your body to the beat of a drum, scribble a line of poetry across a napkin, listen to the wisdom of your heart, or birth an extraordinary idea into the world. Why do these seemingly simple acts pack so much transformational punch?

Allowing creativity to move through you will eventually—if not immediately—change you.

When you trust and honor the innate wisdom of your body, mind, and spirit enough to create something out of nothing, you willingly put yourself in the driver's seat with no map and no clear destination. This is especially true when it comes to brave, intuitive painting.

With no formula or predictable outcome in sight, every moment becomes a courageous adventure in trust.

Each brush stroke, color choice, and micro-decision leads you *somewhere*, but your eventual destination is not yet clear. In fact, you might not even know the language or the accepted codes of conduct in this wild, creative place. You just know you're the one behind the wheel.

If you've ever traveled or painted in this unpredictable way, you probably know how unsettling it can be—perhaps even a little scary at times. However, this a small price to pay for the remarkable growth, freedom, and personal discovery available when you put yourself on the edge of what is known and trust that you will eventually find your way through.

Thankfully, painting provides a safe, forgiving, and dynamic place to practice the art of letting go without a

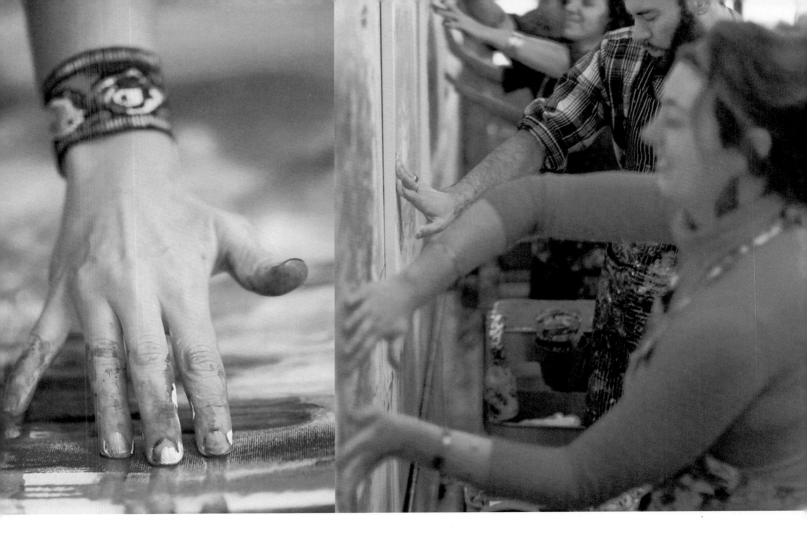

whole lot at stake. While choices in the creative process can feel momentous at times, it's important (and relieving) to remember: *It's only paint. So why not give it a go? Why not do the thing your soul is craving? Why not pick up a paintbrush and see where it leads you?*

Intuitive painting offers a rare and wonderful opportunity to loosen your grip of control, dig beneath the surface of your daily existence, and respond spontaneously to ever-evolving circumstances. In this way, painting allows us to become the alchemist of our own unique experiences, while providing a tangible vehicle for expressing them to the world.

When done with courage, integrity, and heart, these gutsy creative acts have the capacity to connect, empower, enlighten, and ultimately heal.

Even if your creations never leave the kitchen table (and this is a perfectly fine place for them to stay), you were still brave enough to show up without a map, trust your personal ingenuity, and attempt to express what stirs your soul. This, my friends, is what matters most.

We all have infinite wells of creative capacity just waiting to be tapped and remembered, and it's my sincere belief that we *are* remembering.

All around the world, a genuine desire to create personal and meaningful creative work is growing and becoming more and more necessary. While complex global situations intensify, we are being called back to a time when creativity was both an essential part of survival and an integral part of human expression.

A creative revolution is brewing. Can you feel it?

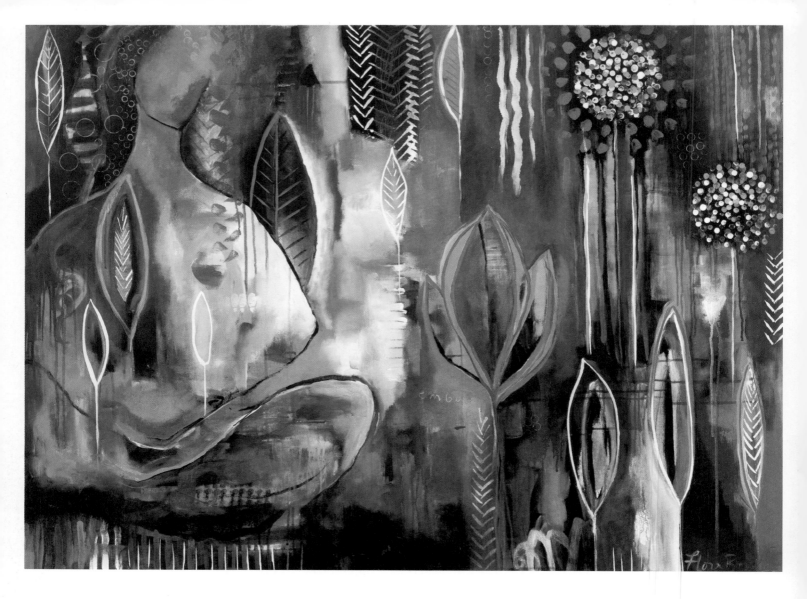

MY **STORY**

If you're wondering, *"What the heck is brave intuitive painting?"* I'm happy to share a bit of my story.

Born in Green Bay, Wisconsin, to two dynamic, free-thinking, YMCA directors, I was raised in a world where health, community participation, and the body-mind-spirit connection laid the foundation for my everyday life. As a little person, I was free-spirited, imaginative, active, and loved. I was also incredibly shy, and I found my greatest comfort and joy in the creative process and the natural world.

Thankfully, I was given space to roam, freedom to think outside the box, and encouragement to follow my heart. I grew up knowing that (some) rules are meant to be broken and doing it my way was more important than fitting in any particular box.

Creativity and resourcefulness were also core values in my family. I made art out of whatever I could get my hands on, and I grew up thinking my seaweed jewelry, watercolors, and clay pots were all worthy works of creative expression.

I was encouraged to do what I loved, and this set the stage for a lifetime of doing just that.

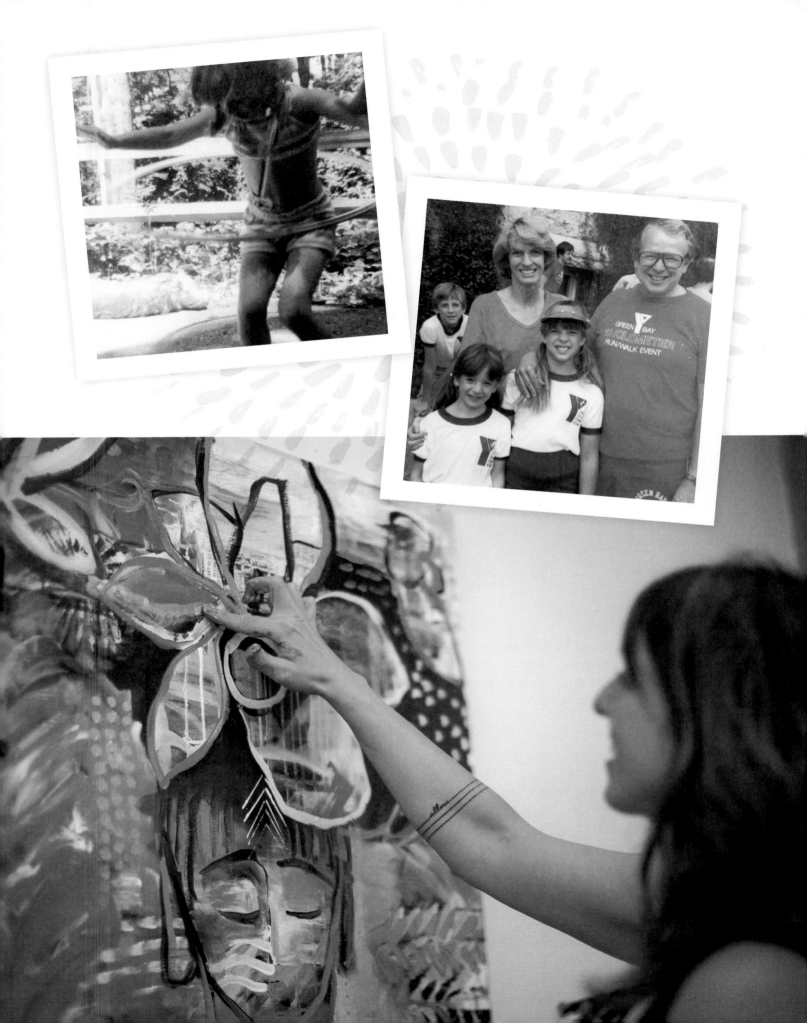

DISCOVERING PAINT

When I took my first painting class in college, my heart raced. My love of color, form, and freedom merged on the canvas—and everything felt possible. This new medium was fluid, invigorating, and challenging in all the right ways. I was in love.

I signed up for every painting class I could, and I began experimenting with oils, acrylics, watercolors, and gouache. Living in the Colorado Rockies, I drew inspiration from the world around me, painting bright, loose, colorful renditions of the barns, horses, mountains, and trees that I saw every day.

Each painting taught me something new and fanned the flames of my newfound passion.

One day, my favorite painting teacher pulled me aside, looked me in the eye, and said, *"You're a painter."* Those words rippled through me like truth, and I took them to heart.

At age twenty, I had my first solo show in a coffee shop. After selling a few of my paintings, I thought, "Maybe making art could actually be my *JOB?*" This was a revolutionary game-changing idea, and one that would change the course of my entire life.

After attending three colleges with various breaks to indulge my love of snowboarding, travel, and soul searching, I graduated with a B.F.A. in painting and drawing. I had a handful of local solo shows under my belt, a dream to be a full-time painter, and adventure in my heart.

A BLESSING IN DISGUISE

After college, I was immediately rejected by all three M.F.A. graduate programs I applied to—a truly humbling blessing in disguise. While these rejections were heartbreaking, they didn't stop me from pursuing my dreams. Instead of going back to school, I followed my adventurous knowing heart. I spent the next ten years migrating around the West Coast—painting, dancing, exploring, following my wild whims and discovering my bohemian tribe along the way.

I lived simply—pinching pennies, squatting in warehouses, living out of my van, and working as a waitress and house sitter. Later, I became a yoga teacher and massage therapist—all the while painting in bedrooms, basements, backyard shacks, and garages. During one particularly romantic summer, I camped in a national forest and painted in my nearby storage unit—anything to keep my passion of painting alive.

At the heart of everything I did, there lived a burning desire to expand, explore, and create—to rub up against what was known, understand my deeper purpose, and unveil my personal and spiritual truths. I had many adventures during those days, and each one shaped the very core of who I am and how I see the world.

These years of soul searching also changed the way I paint.

"Your life is already artful—waiting,
just waiting for you to make it art."
—TONI MORRISON

ART REFLECTS LIFE
LIFE REFLECTS ART

I started to see my painting practice as a reflection and extension of my life *off* the canvas, and vice versa. I was learning new life lessons at every twist and turn, and painting gave me a place to practice these "new ways of being."

Leaving the horses and barns behind, my painting style began to evolve to fit my growing desire for more spontaneity, freedom, and change. I happily let go of preplanning, and I allowed my paintings to morph organically through layers of intuitive marks and color.

By courageously embracing the mystery, staying open to change, and trusting the journey from moment to moment, my paintings and my life became more and more authentic and dynamic. And so did my life.

I acquired new painting techniques through genuine inquiry, and I tried my best to avoid creative ruts. If I felt stuck, I turned the canvas upside down, changed colors, or picked up a new tool. My repertoire of images and ideas came straight from my life experience through sketching, photography, and a general sense of curiosity.

It seemed the more fully I lived my life, the more I had to work with when I stepped up to the canvas.

Through many years of dedication, experimentation, breakdowns, and breakthroughs, my understanding of painting grew slowly and steadily right alongside my understanding of self.

By my mid-twenties, my paintings were selling regularly in galleries, cafés, and art fairs, and my colorful, layered, intuitive style felt distinctive and new. The Internet was just starting to emerge and new opportunities were springing up left and right. I was hustling hard and barely squeaking by, but I was proud to be supporting myself as a full-time artist by the time I turned thirty.

Needless to say, these years were full of passion, grit, and adventure. There was little predictability, no particular formula to follow, very little money, and a serious lack of obvious outcomes. Instead, there were dreams fueled by passion, adventures sparked by curiosity, and a deep unrelenting desire to follow my heart and live life on my own terms.

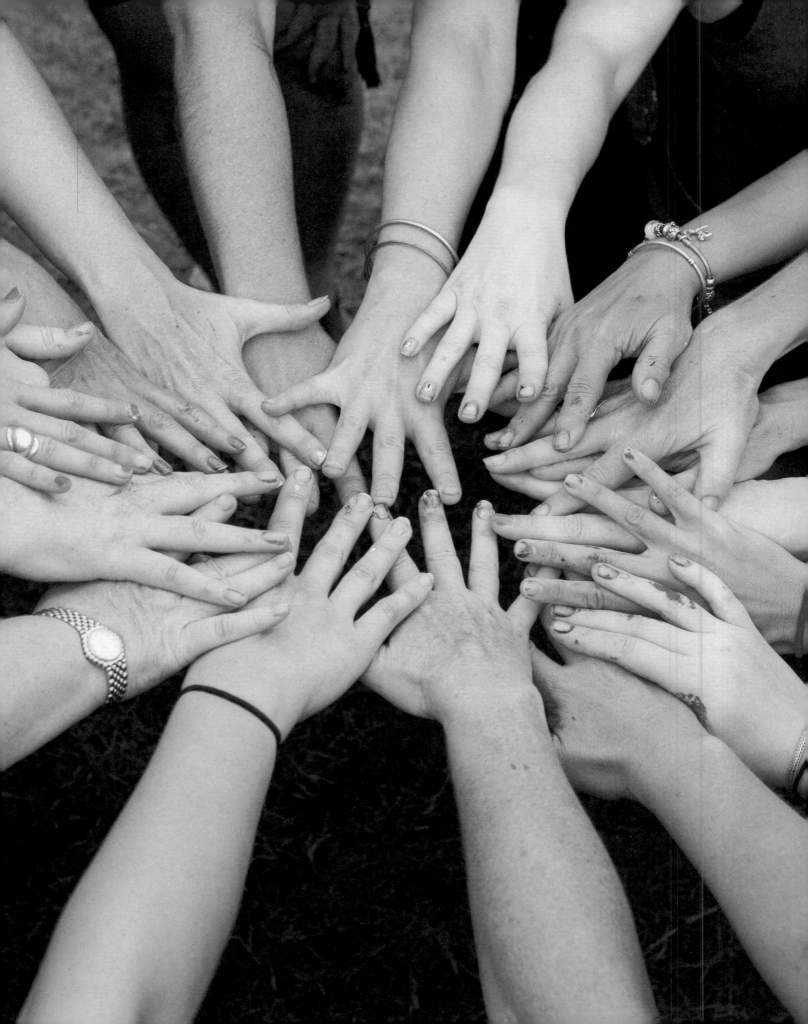

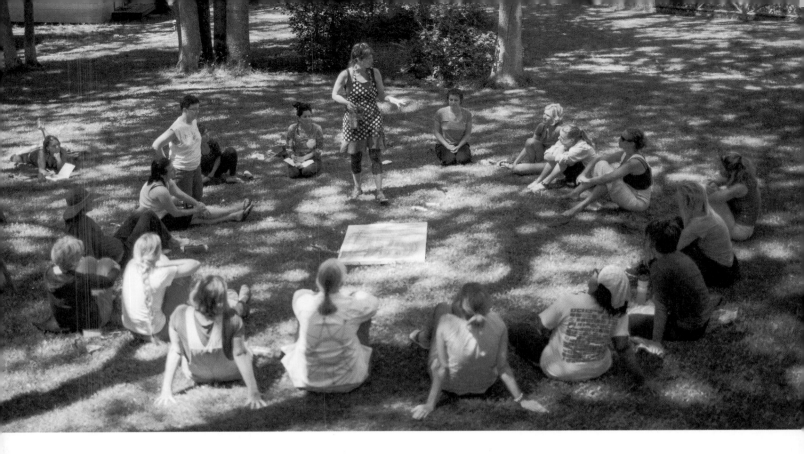

PEOPLE, PASSION, AND PURPOSE

In 2015, I volunteered for six months in the Gulf Coast after Hurricane Katrina. After that life changing experience, I traveled to Costa Rica for some much-needed recuperation. On that trip, I jokingly decided to call myself Flora because "Shannon" was not the easiest name to pronounce for all my new Spanish-speaking friends. After an unexpected turn of events, I ended up officially changing my name from Shannon to Flora, and life was, again, never the same.

Beyond shocking my parents (and myself to some degree), changing my name symbolized a massive and powerful personal transformation. It marked a huge shedding of stories, patterns, and beliefs I had held about myself for so many years. I was ready to move past decades of insecurities and shyness that were holding me back and keeping me quiet.

I was ready to step into a much more empowered version of myself, and her name was Flora.

Around this same time, I had another serious realization: My dream job of being a full-time artist—the thing I had worked so hard to achieve for so many years, the thing that was finally happening—was actually not my dream job after all. In fact, I was feeling more and more isolated with each passing year alone in my studio.

I craved people, passion, and purpose.

I knew there was something more for me to do, but I had no idea what that looked like. I started to share my dilemma with close friends, hoping the more I talked about it, the clearer my path would become. In 2010, my friend, Anahata Katkin, asked me if I ever thought about teaching painting workshops. I had taught yoga for ten years, but had never even considered teaching art—painting was such a personal practice for me at that time.

While I knew there were parallels, my painting practice felt very separate from my healing work and spiritual path, and my love for movement, music, and community lived in a whole different room in my heart. At the time, I couldn't see how much everything overlapped . . . until I taught my first workshop.

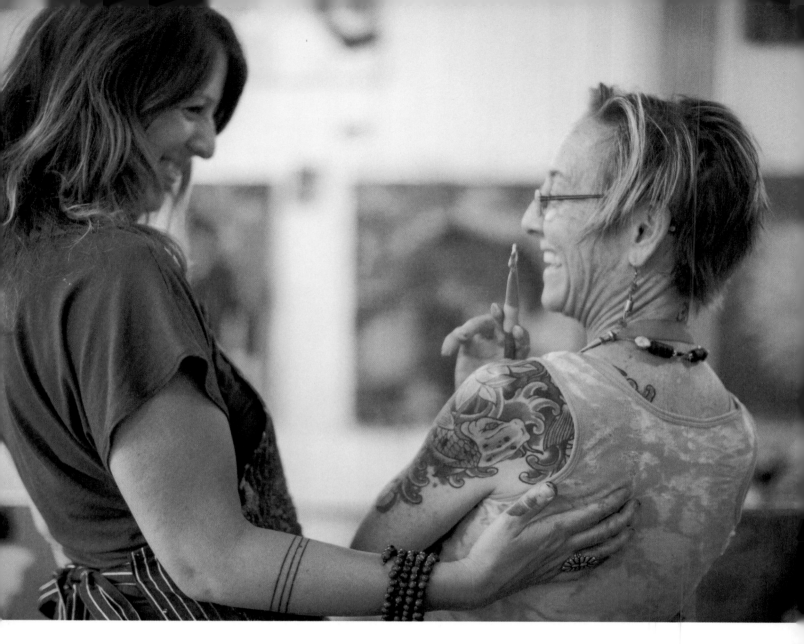

"Though your destination is not clear
You can trust the promise of this opening;
Unfurl yourself into the grace of beginning
That is one with your life's desire.
Awaken your spirit to adventure
Hold nothing back, learn to find ease in risk
Soon you will be home in a new rhythm
For your soul senses the world that awaits you."

—JOHN O'DONOHUE

SHARING IS CARING

I showed up to Squam Art Workshops, in New Hampshire, in the fall of 2010 with very little understanding of how to teach a painting workshop. I walked into my little cabin feeling totally unprepared. I had a few ideas, but I was counting on my years of painting experience to carry me through.

During that pivotal weekend, I taught my painting process to more than sixty women, and the lines between my passions quickly began to blur in the most interesting ways.

We started the workshop with yoga and a walking meditation because that's how I often started my own painting practice.

I read poetry, burned sage, played my favorite music, and made sure we took dance breaks along the way.

We worked on big canvases, loosely layered colors and marks, and allowed images and forms to emerge along the way.

By the end of the workshop, there were more than a hundred large colorful paintings leaning up against the trees outside the cabin. My students (and many passersby) were in awe of their creations.

I was startled with the potent recognition that *this* was my soul's calling—my newfound path. Teaching felt like the culmination of everything I had ever studied, every place I had ever traveled, every risk I had ever taken, and every painting I had ever created.

Looking back, I could see that every time I had followed my brave (often unreasonable) heart, I was taking one step closer to this moment all along.

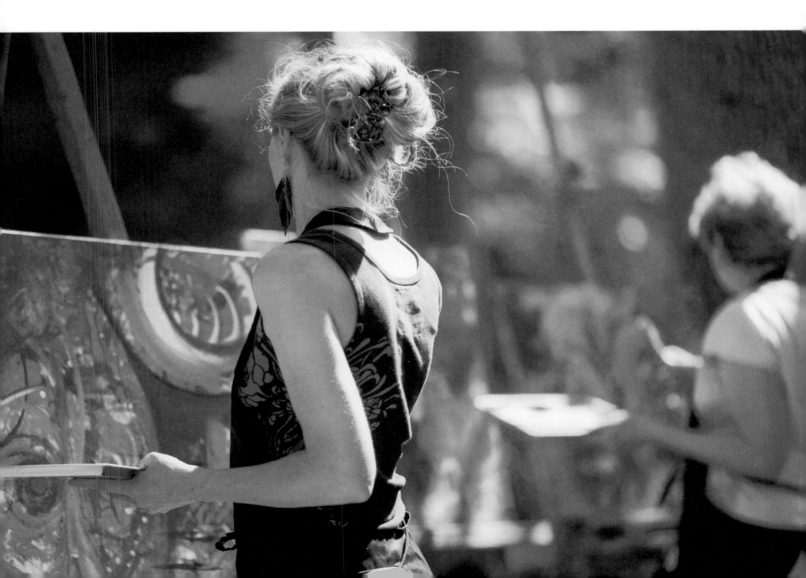

BRAVE INTUITIVE PAINTING

One week after teaching that first workshop I started to receive gracious invitations to teach all around the world. I was also invited to write my first book. To be honest, I was floored by all of the sudden interest in my painting process, but I took it as a sign that I was on the right path.

Almost immediately, I found myself traveling, teaching, and writing my first book in coffee shops, guest rooms, and various corners of the world.

Unbeknownst to me, my years of solo painting practice and personal transformation work were beginning to inspire a much larger community.

Struggling with writer's block one day, I decided to search *intuitive painting* on Google. I vividly remember that moment: I was sitting in a brightly lit kitchen in Portugal after teaching a workshop all day, and I was asking myself, *"What exactly is intuitive painting anyway?"* When I searched the Internet, I was surprised to find a whole wonderful world of intuitive painting spring to life before my eyes—how great!

Curious to learn more about other forms of intuitive painting, I signed up on the spot for a two-day class in San Francisco. Aside from art school, I had never taken a painting workshop in my life, and I was excited to learn from someone else.

When I showed, I was immediately struck by how different the environment felt compared to my own workshops. After one day, I was in tears.

What we were learning in the workshop was absolutely wonderful, but completely *different* from my version of intuitive painting. I thought surely these drastically unique approaches could not both be intuitive painting.

Let's just say I was having a bit of an identity crisis.

"You live out the confusions until they become clear." —ANAÏS NIN

FROM BREAKDOWN TO BREAKTHROUGH

I stuck the workshop out, and by the end of day two I experienced a huge breakthrough.

I realized intuitive painting could actually look many different ways, even if it was called the same thing. Like many other subjective experiences in life, there's simply not one "right" way to express yourself with paint. This is one of the marvelous things about intuitive painting—anything goes!

I left that workshop feeling more grounded in my own approach than ever before. I realized that my passion for moving my body, listening to music, gathering inspiration from the world around me, turning my canvas upside down, and generally following my gut from layer to layer was a beautifully unique approach to the creative process that I had earned through years of personal inquiry and exploration.

Based on the reactions to my first workshops, it was clear that other people were also interested in painting in this way. This was certainly not the *only* way to paint intuitively—it was simply my brave, intuitive way.

The way I see it, painting intuitively (and creating in general) is about honoring what works for *you*. It's about making time for yourself, trusting your heart, and doing what feels genuinely interesting along the way.

With this understanding, I invite you to explore my approach to painting with a sense of playful, open-hearted adventure. Take what works and bless the rest.

As you're doing this, remember to stay closely connected to what makes you feel most alive. Become a keen observer of your own life so you can step up to your canvas with a full cup of inspiration. Weave this information about yourself with the philosophies presented here to create something totally new and unmistakably YOU.

Perhaps your own creative breakthrough is right around the corner?

"Don't ask what the world needs. Ask yourself what makes you come alive and then go do that. Because what the world needs is people who have come alive." —HOWARD THURMAN

BORN TO **CREATE**

As humans, we were undoubtedly born with a vast and amazing ability *to* create, and for thousands of years creativity was a basic part of human survival. However, this kind of necessary resourcefulness inevitably faded when the world became more industrialized and, well, predictable.

But the world is changing once again, and growing complex global and social issues require new ideas, visions, and innovative ways of solving problems. Creative thinking and living has become a necessary part of survival, and new waves of ingenuity are sweeping across every field imaginable.

Simultaneously, many people are feeling called to engage with their creativity on a more personal get-your-hands-messy kind of level. They are being called to this powerful and reflective path to self-discovery as a way to explore the intricacies of human emotions when words just don't cut it.

However, many people are raised in cultures that do not foster creative expression and view artists as a rare and special breed.

Considering the lack of arts education and the commonly held belief that only a small handful of "talented" people can actually be artists, it comes as no surprise that many adults are quick to say, *"I'm not an artist."* Or my personal favorite, *"I can't even draw a stick figure."*

But the desire to create remains.

ACCESSING CREATIVITY

What I find particularly disheartening about the dismissal, avoidance, or lack of self-confidence surrounding personal creative freedom are all the missed opportunities.

If you immediately discount the idea of being creative, how will you ever know the joy of painting with your fingers to the beat of a drum, or experience the satisfaction of expressing what is only possible to say through color and form? How will you discover what your unique expression actually *looks like* if you never give yourself the chance to birth it into being?

Walking a creative path is not a linear experience. It is a meandering journey that invites you to explore the complex, often ambiguous mysteries of life, while strengthening your understanding of self along the way. It's also a mighty fine time to play and have fun!

It is my passion and great honor to invite you to explore this path, broaden the scope of what feels possible and light the way toward a more universally empowered and authentic way of creating.

I believe expressing ourselves in this brave intuitive way has the power to open hearts, shift perspectives, change lives and ultimately heal the world.

I believe in creative revolution.

"It took one single moment to change my life. With absolutely no training in art I put paint on the canvas, got my hands full of paint and made a glorious mess. What I discovered was it really had nothing to do with WHAT I was painting, it was all about what was happening inside when I painted."

—LARA CORNELL (BLOOM TRUE STUDENT)

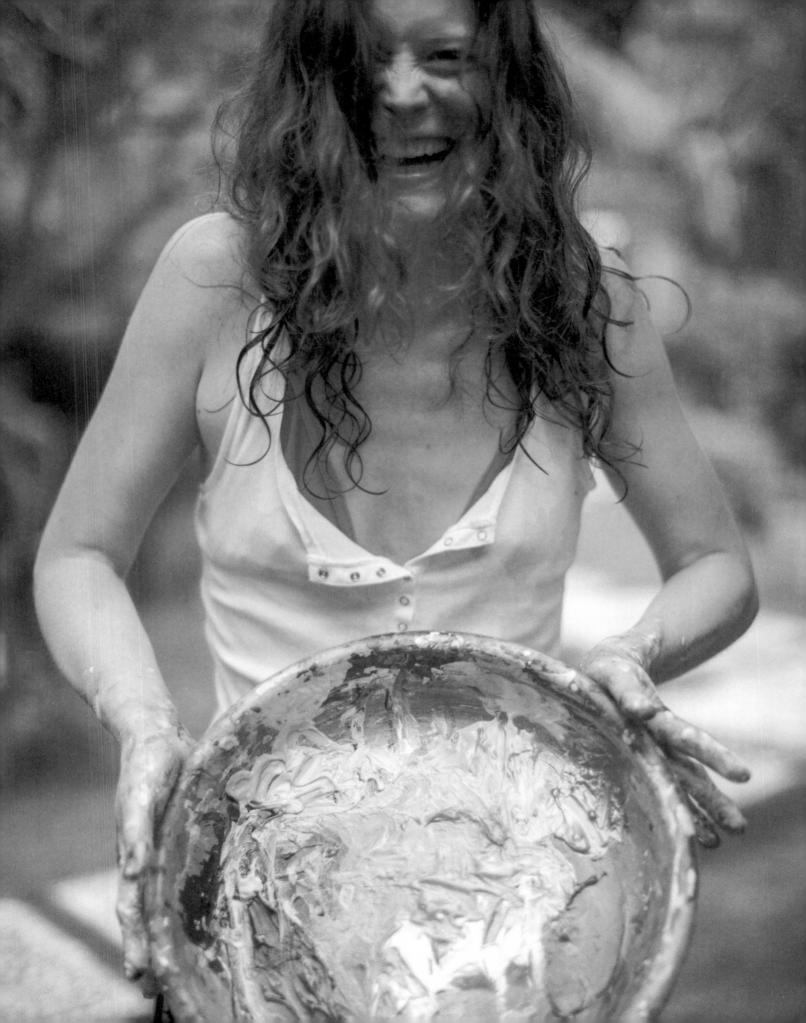

PERMISSION TO CREATE

Since publishing *Brave Intuitive Painting* in 2012, I've had the honor of sharing my painting process with thousands of people, both online and in person. One thing I've noticed is that my students often show up in the midst of some pretty serious transitions. Fundamental life changes such as retirement, divorce, illness, birth, death and kids leaving the house all provide fertile soil for creative revival and spiritual awakening.

When people walk through my studio door, they often show up with a strong willingness to move through these transitions and an eagerness to experience what's on the other side. Even if they have no idea what to expect, there's usually a glimmer in their eye and a childlike nervousness in the air.

I'm passionate about creating a safe place to explore the depths of whatever wants to emerge on the canvas or in our sharing circles, and I often begin my workshops by asking my students, *"What stirred your soul so much that you decided to take four precious days out of your busy life . . . to paint?"* Sitting in a circle around a simple altar, the answer is rarely *"To make pretty paintings."*

While creating beautiful things is often the end result of our soulful days together, it is usually not the intention going in. We're all here for something greater—something much more layered and deeply personal than making pretty pictures to hang about our sofas. We're here because we followed a deep soul craving to show up, get messy, and explore the wild unknown through paint—and this calling could not wait any longer.

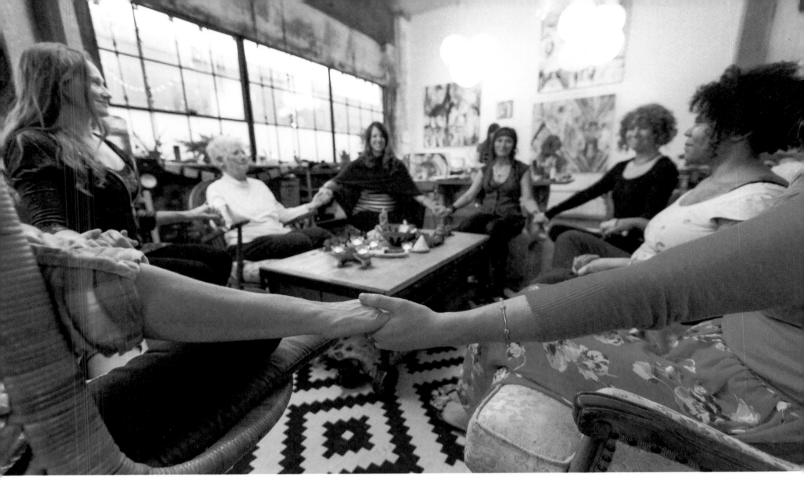

"It truly is amazing the difference I have felt standing in front of the canvas with permission to just let it all go, make a mess, have fun, laugh, cry, dance, play with paint, and know that deep down I am an artist."

—DANELLA WHITTAKER (BLOOM TRUE STUDENT)

To create a simple heart-felt ritual around this potent new beginning, I follow up by asking, *"What kind of experience are you craving, and what are you willing to let go of in order to have that experience?"* I encourage everyone to speak their desires out loud and drop a stone into a bowl of water to represent what they are letting go of.

I'll tell you this. What I hear time and time again is a readiness to invite more freedom, peace, spontaneity, compassion and intuition into the forefront, followed by a desire to let go of control, anxiety, fear, procrastination, and negative self-talk.

These desires are often followed by familiar, heart-breaking stories of squelched creative freedom, lost artistic passions and life getting too busy to create anything beyond breakfast, lunch, and dinner. Many of the people in these circles are women, and most of them have spent their life prioritizing everyone around them before themselves.

Sound familiar? You are not alone.

CLAIMING A CREATIVE SPACE

Getting creative with your creative space is a powerful first step on your journey.

Like most things that are good for us and absolutely worth doing, the hardest part is often showing up and starting. Once we leap these great hurdles (which usually aren't that great after all), momentum and inspiration have tremendous power to keep us going.

There are two crucial steps you'll need to take to set yourself up for an awesome painting journey. You need to set up a space to paint, and gather your supplies.

If *"I can't create art, because I don't have the space..."* sounds like a familiar story, now is your time to reboot that belief system. Carving out actual physical space sends a tangible message to the Universe, yourself, and the people around you that you are serious about your creative path. It also makes it a heck of a lot easier to actually make art.

Where can you make a little space for yourself? It might be the kitchen table or in the corner of your bedroom. Perhaps you have a friend who would happily lend you a some of their extra space to support your dream?

As I mentioned, I spent years painting in all sorts of decidedly unglamorous makeshift studios. Basements, bedrooms, garages, and backyard shacks can provide ample space to create and explore. Remember your creative space doesn't need to be fancy. It just needs to be yours.

Your art supplies don't need to be fancy either. I painted with house paint on cardboard until I could afford better materials. The point is, do what works for YOU, but do *something* to give yourself space to create.

As you carve out your creative space, consider infusing your space with some simple nurturing items, inspiration, and good energy. This doesn't take a whole lot of effort, and when you create an environment you *love* to be in, it's much more likely you'll actually go there.

So love it up!

Is there a way to play music in your space? How is the light? You can easily liven things up by adding some simple speakers and clip lights from the hardware store.

Do you need to cover any surfaces so you can freely make a mess? A large drop cloth can quickly give you the freedom to do just that. Maybe you want to build a small altar or add some meaningful and inspiring objects to the space? What about a pillow zone or a comfy chair to relax in? Consider making a *Please do not disturb. Busy making art!* sign to hang on the door.

It's time to consider your creativity a priority in your life. Why? Because creativity is a crucial part of your well-being and it's worth prioritizing.

"Your own reasons to make art are the reasons enough. Create whatever causes a revolution in your heart."

—ELIZABETH GILBERT

GATHERING YOUR SUPPLIES

Now that you have created your space, it's time to take a look at your current art supply situation. If you are at all like me, your assortment of art goodies could probably benefit from a little sorting, editing, and organizing.

I'm admittedly addicted to buying art supplies, but I also *love* to organize them before I paint. There will always be messes made in the creative process, and this is part of the fun, but starting with a fresh slate allows for clear energy and inspiration to flow through easily.

If you don't have any art supplies or you need to upgrade your stash, this is a great time to stock up. Don't get too hung up on the technical aspects of each material or color. Instead, buy supplies based on what makes your heart beat faster. This is a great time to start following your intuition.

If you're on a budget, I suggest putting out the call to your community. There's a good chance someone will happily pass on some of their supplies to help out an inspired friend. Also keep an eye out for sales at art supply stores. Many stores offer great deals on a regular basis.

Remember, it's totally fine to keep it simple. It's amazing what you can do with good old-fashioned markers, a basic set of acrylic paints, crayons, paper, and an open mind. If you're ready to stock up a little more, here's a list of some of my favorite supplies and suggestions to get you started.

ACRYLIC PAINT

ACRYLIC PAINT When it comes to paint, you often get what you pay for. However, the most important thing is that you feel free when you are painting. If you are reluctant to use your more expensive paints, you might not be able to access a sense of freedom, so please buy paints with this in mind.

If you crave the luscious pigments that only more expensive paint can offer, one solution is to use cheaper paint in your first layers and save your more vibrant, expensive paints for your final layers.

Having a variety of paint thicknesses will also give you more options. I love using GOLDEN brand's heavy-bodied paints when I want to build up a thick buttery texture, and their fluid paints when I want more translucent thin layers.

Helpful hint: If you're able to buy one tube or jar of high-quality, heavy-bodied Titanium White, you can mix this paint with all your other colors to create more opaque versions of them—a great way to alleviate the frustration that can come with cheap translucent pigments.

If you are wondering what colors are best to start with, choose a basic set containing white, black, red, blue, and yellow. Limiting your colors in this way will likely inspire you to mix your own colors from the primaries, and that is a wonderful way to learn about color. Of course, you are welcome to start with or add more colors along the way. Growing your color collection is such a fun part of the painting process!

ADDITIONAL SUPPLIES

PRE-PRIMED AND PRE-STRETCHED CANVAS I find working on larger canvases helps me to free up and explore. Some of my favorite canvas sizes are 36" x 36" (91 x 91 cm), 48" x 48" (1.2 x 1.2 m), and 48" x 60" (1.2 x 1.5 m). However, please work on any size canvas that fits in your life—and car!

HEAVY PAPER If you don't want to work on canvas, you can also paint on any kind of heavy paper that can handle wet mediums such as paint. I enjoy working on 140 lb or 300 lb watercolor paper, and I often choose the 30" x 22" (76 x 56 cm) standard size.

OTHER SURFACE OPTIONS Other surface options include: Pine or masonite panels (from the hardware store), old paintings from thrift shops, cardboard, old wood, or doors. Some of these alternative surfaces might not hold up over many years, but they are great for practicing and learning.

BRUSHES You are welcome to use any brushes you enjoy for this process. I started using foam brushes back when I couldn't afford anything else, and they are still my most beloved brush today. I prefer Poly-Brush brand foam brushes from the hardware store because they are sturdy and stiff. I also use a variety of cheap bristle brushes from the art supply store. I suggest buying a variety of shapes and sizes, and make sure you have at least one small brush with a pointy tip for details.

ACRYLIC GLAZING MEDIUM Glazing medium isn't essential, but it is nice to have on hand, especially if you don't have any fluid paint. Glazing medium is great for thinning paint to create translucent layers. I love gloss medium, but any finish will work.

OTHER PAINTING TOOLS It's fun to use a variety of etching and stamping tools, such as old pens, bottle caps, bubble wrap, veggies, and combs to expand your repertoire of unusual tools. Each new tool offers a new set of marks, and this is a great way to expand your visual language. There's no need to buy anything new, just look around your world and be creative!

PALETTE My favorite palette is a sheet of glass with a piece of white paper underneath. To clean your glass, simply let your extra paint dry, spray your palette with water and scrape your paint off with a razor (always be very careful!) If you are using a glass palette, please tape the edges for safety. Cookie sheets, muffin tins, or palette paper will also work well as palettes.

WATER SPRAY BOTTLE I use my beloved spray bottle to make drips and to keep my paints from drying out on the palette—an essential tool especially in warm, dry climates.

JAR FOR WATER Keep a jar of water next to your paints to put small brushes in where you aren't using them. Little bristle brushes will dry out quickly if you don't keep them immersed. I prefer to keep my foam brushes directly out on my palette while I'm working. Just spray a little water on them to keep them from drying out.

RAGS This is a messy process, so it's important to have some rags nearby for cleaning up. Old towels or sheets work great!

BARRIER CREAM OR PLASTIC GLOVES While acrylic paint is low in toxicity compared to oil paints, there are still some pigments that contain potentially harmful properties if you are exposed to them for long periods of time. To give your hands a bit of protection and to make the clean-up process easier, you can apply barrier cream to your hands before painting. You can also wear plastic gloves, if you prefer. This is a personal choice so do what feels best for you. My favorite brand of barrier cream is called Invisible Care (by EZ Air).

INTEGRATED CREATIVITY

In *Brave Intuitive Painting*, I open with this personal reflection:

"For many years, I struggled with my desire to paint for the sake of exploration, raw expression, and release. I thought my art needed to support an intellectual theory, make a political statement, or in some way change the world. Eventually I surrendered, allowing myself to paint for the sake of painting and the joy it brings. After many years of following my heart, I now understand that the very act of pure expression does change the world. It changes each and every person who is brave enough to pick up a paintbrush, open themselves up to the unknown, and express themselves honestly and intuitively. It is through this kind of heartfelt expression that truths are revealed, lives transform, and new worlds are born."

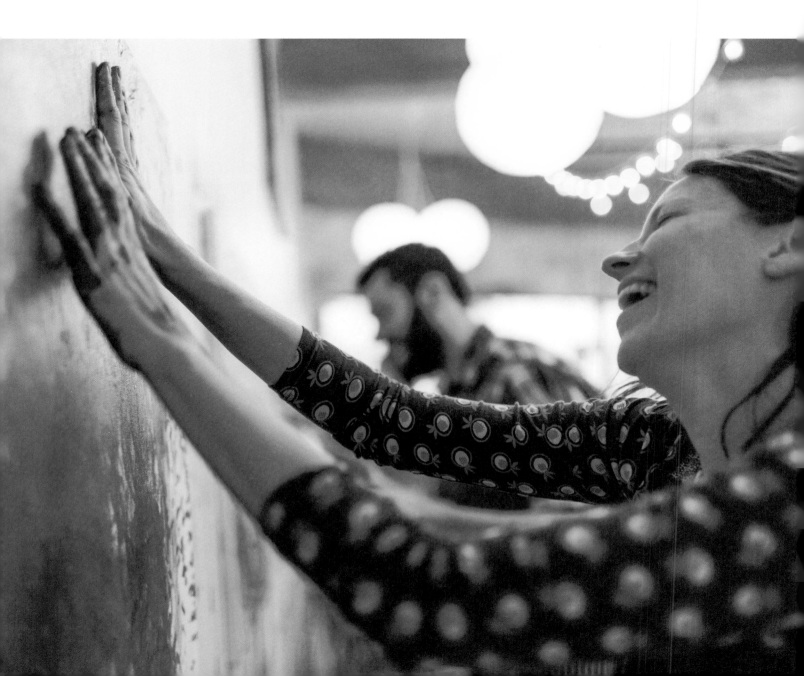

"A bird doesn't sing because it has an answer.
It sings because it has a song."

—MAYA ANGELOU

I wrote these words based partly on my own personal experience as a painter and partly on the blind faith I had in the creative practice. Fast-forward five years, and I couldn't agree with them more.

Since writing my first book, I've had the unique and exquisite opportunity to guide thousands of people through my brave, intuitive painting practice. This front-row seat has allowed me to witness incredible breakthroughs and personal transformations sparked by the creative process.

I can now say with the utmost confidence that picking up a paintbrush without a plan is a lot like picking up a profound and truthful mirror. This compelling mirror has the ability to show us what's working or not working in our lives, while offering a safe and accepting place to practice new, more empowered, ways of being.

For example, turning up the music, closing your eyes, and allowing your body to dance with paint can remind you that letting go of control (even for just a song)

is incredibly energizing and fun. On the other hand, if making commitments is more of your challenge, try painting with a limited palette and strong familiar shapes to strengthen your resolve.

The more familiar you become with the breadth of creative outlets available, the easier it becomes to support your ever-changing moods and natural oscillations with the exact form of creative medicine needed.

There is no rhyme or reason to what will captivate your creative spirit on any given day. Allowing these tides to ebb and flow, and responding to them with curiosity and heart, honors the rhythms of your life.

One day painting with your feet might give you the taste of wild abandon you're deeply craving, while sketching quietly might fill your well of inspiration the next day. Creative practices can also light a path through grief by soothing your soul and offering a unique portal to the other side.

BODY, MIND, AND SPIRIT

There are infinite opportunities to explore living through painting (and vice versa).
I'm particularly interested in how each opportunity calls upon unique aspects of the
body, mind, and spirit. The delicate interplay between these three wisdom centers
offers an extraordinary opportunity to expand our integrated understanding of self,
while strengthening each individual muscle along the way.

To explore this holistic approach to the creative process, I've divided this book into
these three sections: Body, Mind, and Spirit.

From shake-your-booty spontaneity, to well-thought-out conceptual ideas, and all
the unexplainable magic in between, honoring the wisdom of your body, mind, and
spirit breathes life into *all* your magnificent dimensions and offers them a safe place
to mingle and play.

"In your light I learn how to love. In your beauty, how to make poems. You dance inside my chest, where no one else sees you, but sometimes I do, and that sign becomes this art." —RUMI

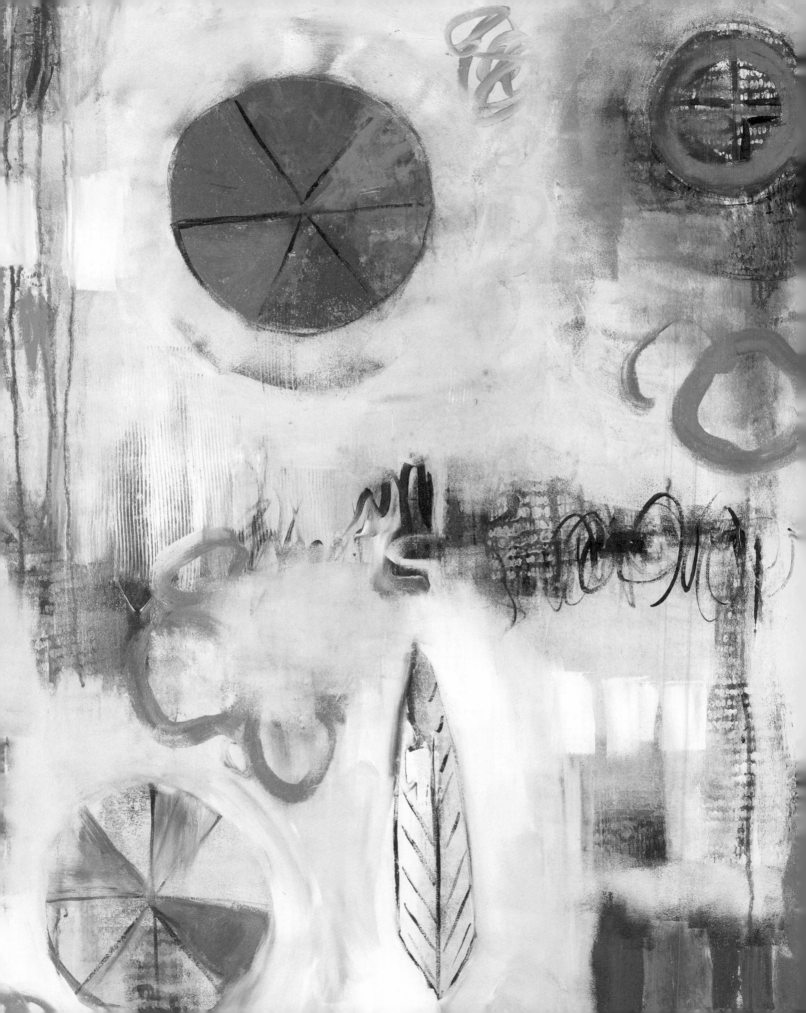

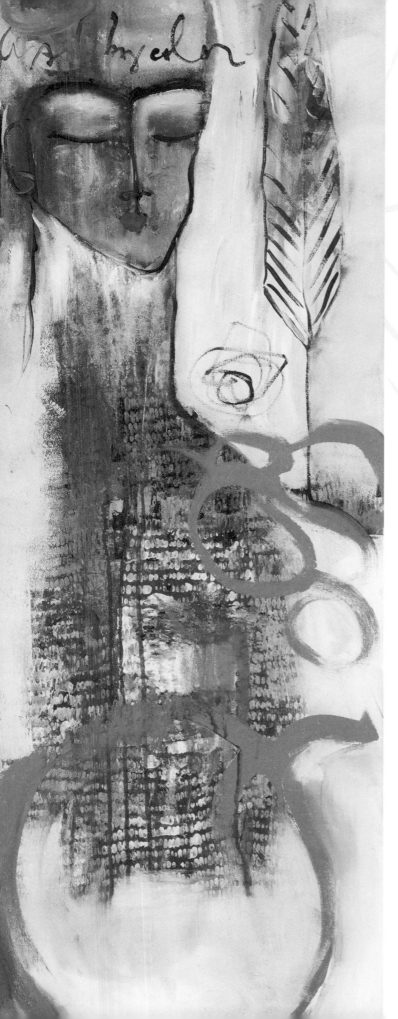

INSEPARABLE PARTS OF A BEAUTIFUL WHOLE

Your body, mind, and spirit are inseparable parts of a beautiful whole, each encompassing unique facets of wisdom, purpose, and functionality.

By calling upon and integrating this dynamic trifecta of knowledge, you can offer a voice to every aspect of who you are and what you bring to life – both on and off the canvas.

For the purposes of this book, I've chosen to look at the distinct potentialities of body, mind, and spirit and how they can support and inform your creative process. When their wisdom overlaps, we can find our flow within these blurred edges.

If you've ever wondered if a creative choice was inspired by the wisdom of your heart, the stirrings of your mind, or the inexplicable mysteries of your soul, it's likely a bit of everything.

We are complex creatures living in an equally complex time, but creative pursuits can shed much needed light on these intricacies while offering solace and reprieve along the way.

"I just can't imagine art not being in my life. To me the process of painting is more than life changing, it's life saving."
—DEBRA SUTTON (BLOOM TRUE STUDENT)

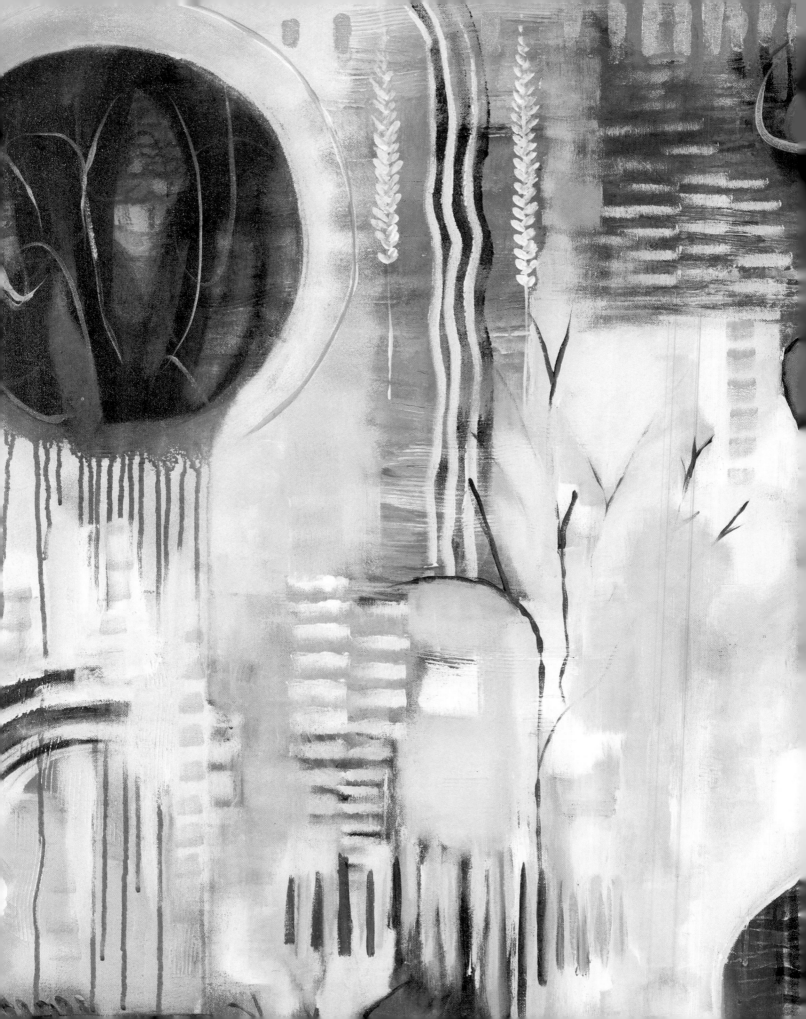

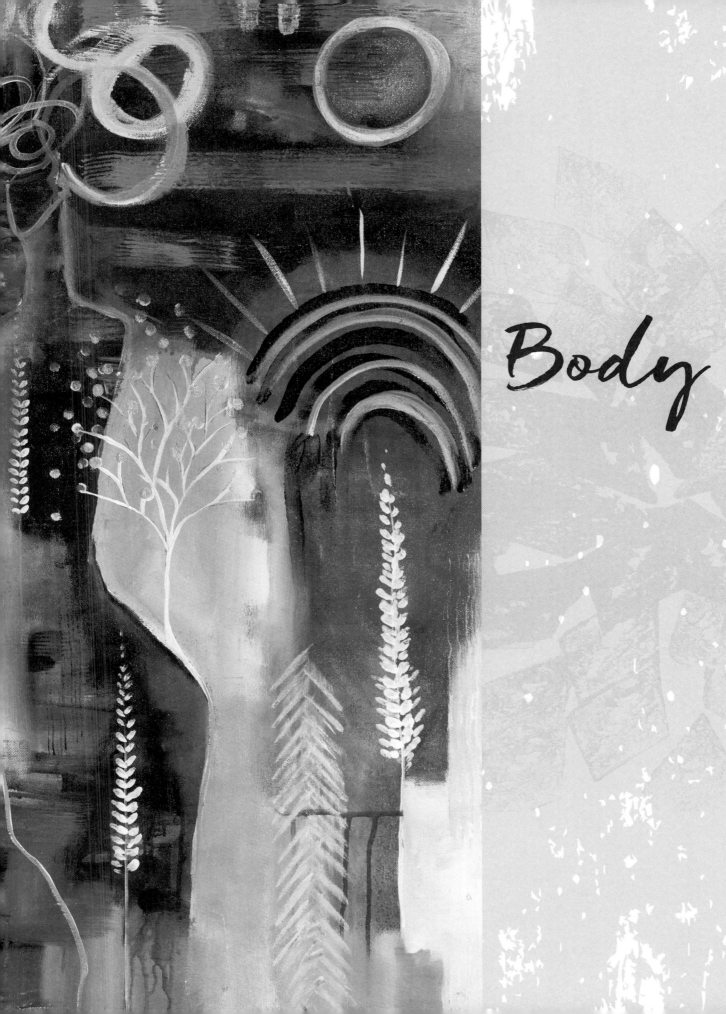

Body

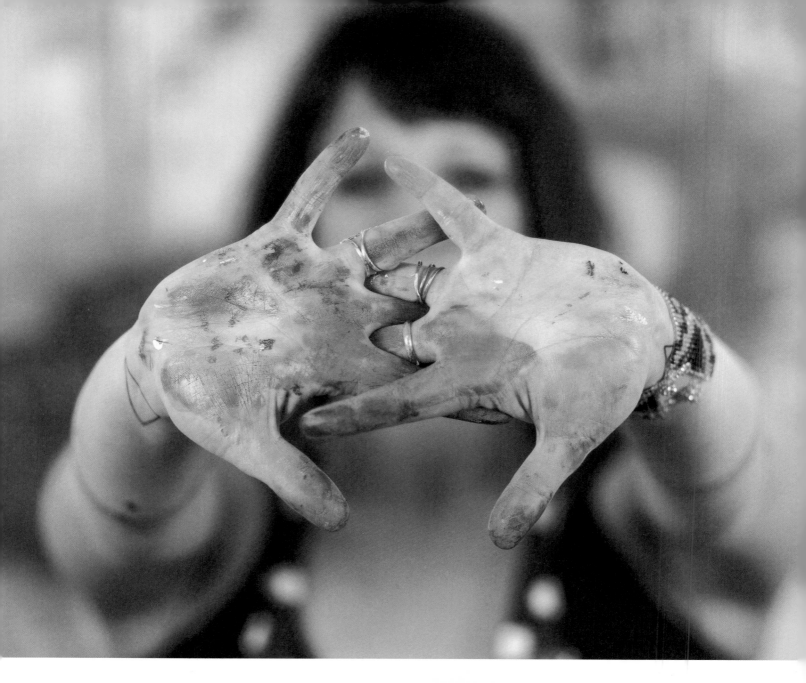

THE **MOVEMENT** OF CREATIVITY

I'm a mover—always have been.

As the daughter of two YMCA directors, I did a lot of my growing up at the Y. During those years, my mom pioneered many new programs that brought awareness to the connection between the body, mind, and spirit.

She believed this connection played a major role in building self-esteem and trust in early childhood development, and she worked her whole life to help children do just that.

While my mom spent her life helping people become more connected to their whole being, I had the unique experience and privilege of being her "demo kid." From the time I was born, I was given an intimate view of her revolutionary methods, incorporating physical movement with mindfulness, spirit, and play.

My natural inclination to want to move my body, coupled with my mom's passionate work, instilled a deep understanding that physical movement was a key part of my well-being, my ability to feel good, and to stay inspired. These unique early experiences shaped the relationship I have to my body and profoundly informed my own life path.

Over the years, I've continued to explore my relationship to movement through my study of yoga, massage therapy and conscious dance. When I began teaching painting, it quickly became clear that my passion for movement was intricately connected to my creative process.

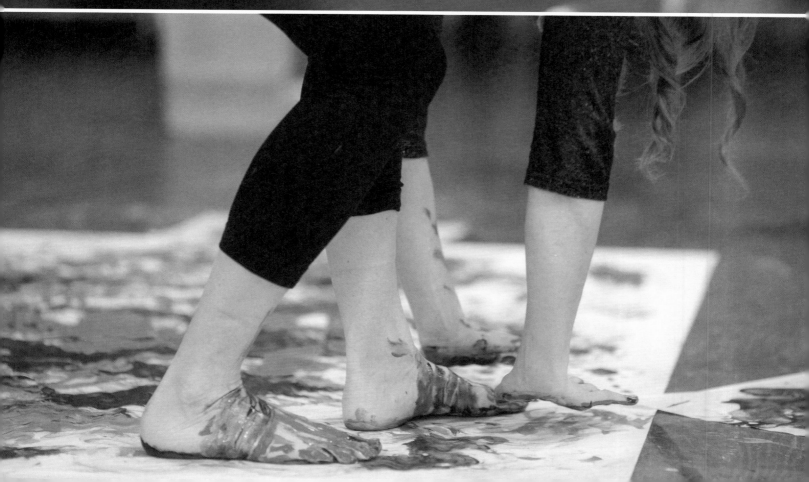

"Great dancers are not great because of technique, they are great because of their passion. Dance is the hidden language of the body. The body says what words cannot."
—MARTHA GRAHAM

INTEGRATION

For many years, my love of movement and my love of art lived in very different rooms in my heart. Nobody in art school was talking about moving our bodies as a way of accessing inspiration. Honestly, there seemed to be a prevalent disassociation to this connection among many of my fellow art students.

In high school, "the jocks" and "the artists" inhabited different worlds, and there was simply no talk of the relationship between creativity and movement.

When I started to share my painting process with others, I immediately recognized that movement is, indeed, a vital part of my creative experience. Stretching before I paint and taking regular dance breaks makes perfect sense as ways to loosen up and get unblocked. I really can't imagine it any other way.

Looking back, I realize this kind of physical integration is simply an extension of who I am and how I was raised. Moving my body and connecting to my breath have always served as tools to become more present, energized, and inspired.

Unfortunately, the practice of creating visual art is commonly seen as a relatively sedentary experience. We are often taught to sit at a table or an easel and let our dominant hand (and mind) do the rest.

I believe there is another, more embodied, way.

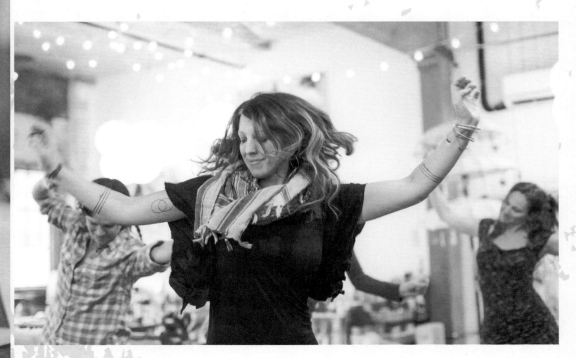

TAKING THE TIME TO **EMBODY AND CONNECT**

In 2010, I taught my first life changing painting workshop—life changing for *me*, that is.

The workshop started with a circle of women standing at the edge of a lake. We placed our hands on our hearts, took a few deep breaths, and made a conscious choice to arrive—in our bodies, in this place, in this moment.

I might've been offering these exercises as a way to calm my own nerves, but they were appreciated by all.

After a few minutes of meditation and simple stretching, we began to walk at a quarter of our natural speed. Allowing our bodies and curiosity to lead the way, we felt the air on our skin, listened to the pine needles crunch underfoot, and started to notice the shapes, colors, and textures from the landscape—we were in such a breathtaking place!

Back inside our cozy cabin, we shared our intentions for our day together, lit a candle, and broke out our paints.

Looking back, I realize this was probably not the way my students expected their painting workshop to begin. They might have assumed we would kick things off with a color wheel or a conversation about sable brushes and mediums, but there's a reason I held off on the technicalities.

The way I see it, slowing down, stretching our bodies, opening our senses to the world, and gathering inspiration from our environment are the first steps of the creative process. These simple gestures bring us back home to ourselves and to the real reasons we are there in the first place.

The technical aspects of painting have a tendency to stop inspired and curious people in their tracks. *"What do you mean there are three types of mediums, and the primary colors aren't actually red, yellow, and blue? Eek!"*

It's easy to get overwhelmed with unfamiliar information. Worrying about doing things "right" has the power to scare perfectly raw, wonderfully spontaneous, human impulses right out the cabin window.

So . . . the lake.

Taking a few minutes to arrive and get connected to our bodies and the environment helps to set the stage for a more open, curious, and integrated way of creating. From this rooted place, painting can be simple, accessible, and one of the most profound ways to learn about yourself.

This is not to say learning technique is unimportant. It certainly is, and this is one of the times our minds can really serve our creative process.

In the Mind section of this book, we'll explore techniques and fundamental art principles, but here's some good news: Contrary to what some art schools might tell you, I believe the best way to learn the technicalities of painting is to simply paint—a lot. Make ugly paintings, mix muddy colors, lose your way, find your way, then lose it again.

Whatever you do, just keep painting. And what better way to keep showing up to your painting practice than to be truly curious, excited, and connected to all the parts of your beautiful being?

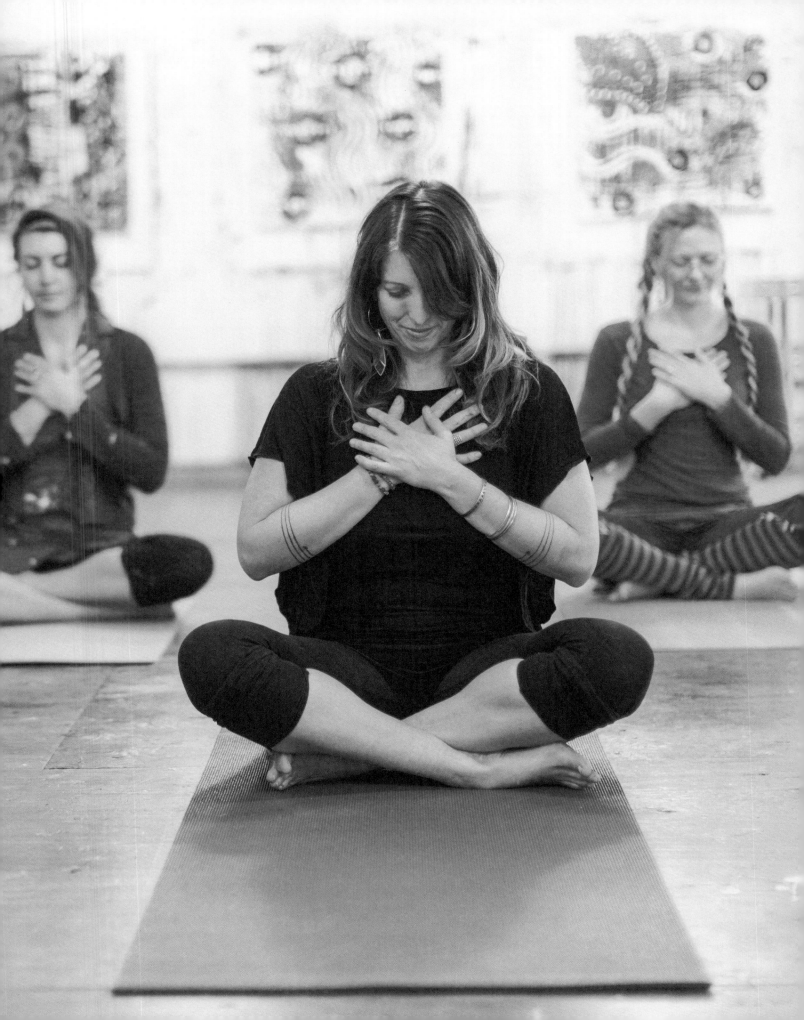

THE PRACTICE

The following section offers a variety of body-based practices to weave into your creative playtime.

If you are open, able, and willing, I invite you to experiment and play with the ideas presented here—please remember there are no rules.

The best way to honor your body is to listen closely to its abilites and limitations, while keeping track of what feels *really good* to you. Notice if you feel more present, energized, and inspired by the activities, and stay open to other ways your body wants to get involved.

Most importantly, enjoy discovering what works for you!

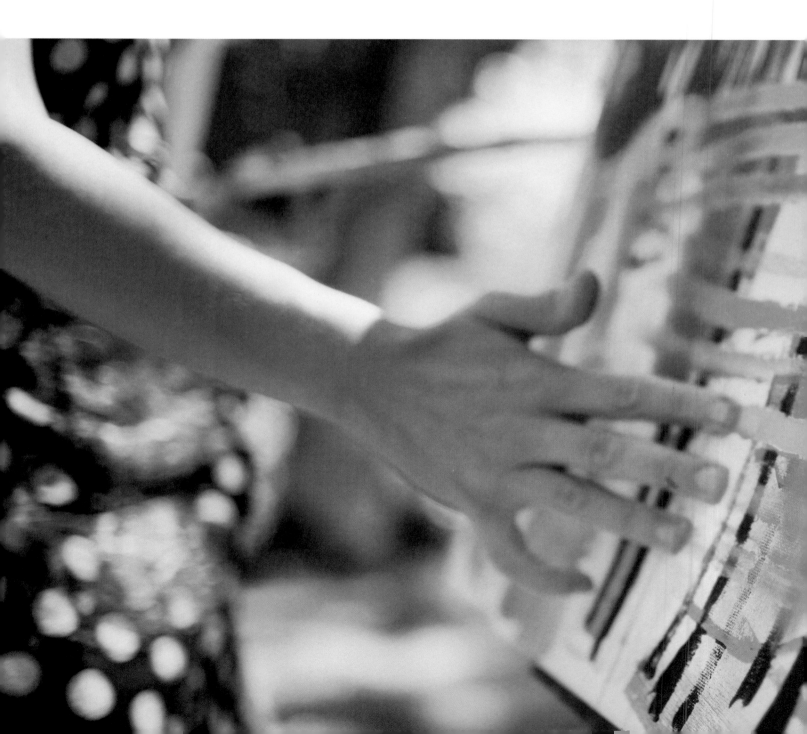

"For me, making art used to be this small thing I did while hunched over at my desk. Opening up to play, dance, stand, work big, be spontaneous, follow my intuition . . . all of this breathed freedom into my art—and into my life! My relationship to making art has shifted from being a mental thing, to being a physically embodied thing. And I feel infinitely more connected and alive as a result."

—DEVON WALZ (BLOOM TRUE STUDENT)

"I took a deep breath and listened to the old bray of my heart.
I am. I am. I am."
—SYLVIA PLATH

THREE-PART **BREATH**

Before we explore movement, let's find our breath. Thankfully, our bodies know how to breathe all by themselves without any extra reminders from us. However, adding a bit of mindfulness to our inhales and exhales allows our breath to do so much more than simply keep us alive.

Conscious breathing is an incredible tool for becoming present, grounded, and connected to our physical body and the present moment—a perfect way to begin any creative practice.

Use this simple three-part breathing exercise before you paint or during your breaks, and notice the effects it has on your body, mind, and spirit.

CLOSE YOUR EYES.

PLACE YOUR HANDS ON YOUR HEART AND BELLY.

TAKE ONE LONG, DEEP BREATH IN.

AS YOU EXHALE, SOFTEN ANY TENSION IN YOUR SHOULDERS, BELLY, AND FACE.

INHALE AGAIN, AND IMAGINE GATHERING ALL THE THREADS OF YOUR ENERGY BACK TO YOUR CENTER.

EXHALE, AND IMAGINE ROOTS GROWING OUT OF THE SOLES OF YOUR FEET, ROOTING YOU DEEP INTO THE EARTH.

INHALE AGAIN, AND FILL YOUR ENTIRE BODY WITH A BRIGHT HEALING LIGHT.

EXHALE, AND LET THIS LIGHT MOVE BEYOND YOUR BODY TO FILL THE ROOM.

CONTINUE WITH MORE BREATHS IF YOU FEEL INSPIRED.

SLOWLY OPEN YOUR EYES.

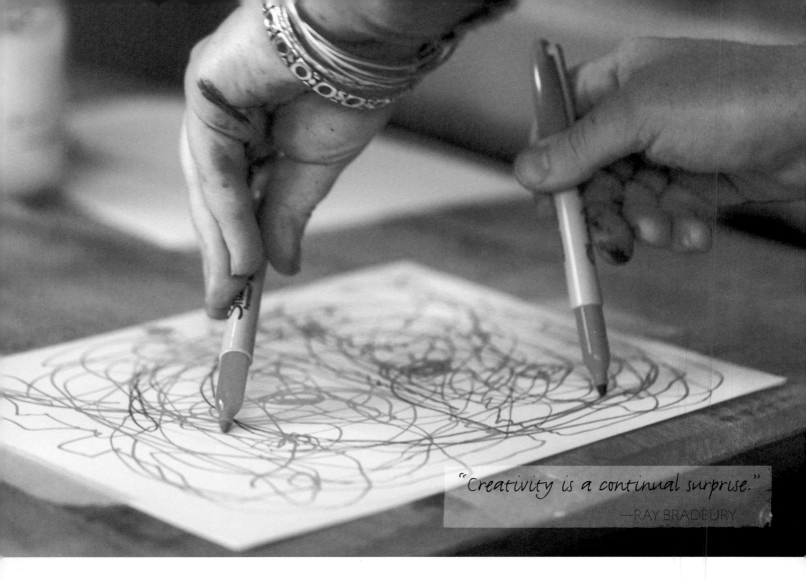

"Creativity is a continual surprise."
—RAY BRADBURY

DRAWING WITH YOUR **NONDOMINANT** HAND

Lately I've been experimenting a lot with "un-perfecting" as a way to loosen up, embrace the grit, and explore new kinds of energy in my paintings. While a highly refined painting can certainly be lovely, I find raw, messy, human expression and experience to be incredibly compelling—and refreshing. I love *feeling* a creation in this way and sensing the experience the artist went through to create it.

One way to achieve this kind of less controlled look is to explore using your nondominant hand.

It's likely that the images, marks, and shapes you'll make with this hand will be somewhat wabi-sabi, unpredictable—and wonderful, adding just the right amount of raw spunk you're looking for. Whereas your ever-predictable dominant hand creations might fall a little flat.

If you're new to painting and drawing, using your nondominant hand can open up some interesting new territory. If you've been drawing or painting for a long time, this exercise will likely breathe some fresh air into your creations.

You can explore this exercise by using markers, pens, or pastels directly on paper. (I suggest taping your paper down to help it stay in place.) You can also play with this exercise by using paint directly on your canvas.

PLAYFUL EXERCISES

— Consider how you are holding your pen or brush. Try holding it in a variety of positions to change the angle and the control you have with it.

— Hold a pen or brush in each hand to experience the difference between your two hands.

— Allow a song to be your guide as your pen or brush moves across the surface.

— Draw something you see in the room using one continuous line.

— Draw a flower, a person, an animal, or something in your kitchen.

— Sketch your usual doodles using your nondominant hand.

— Write words.

— Draw circles, triangles, parallel lines, spirals, and any other shapes you want to explore.

— Want to let go even more? Try closing your eyes while your pen or brush moves across the surface.

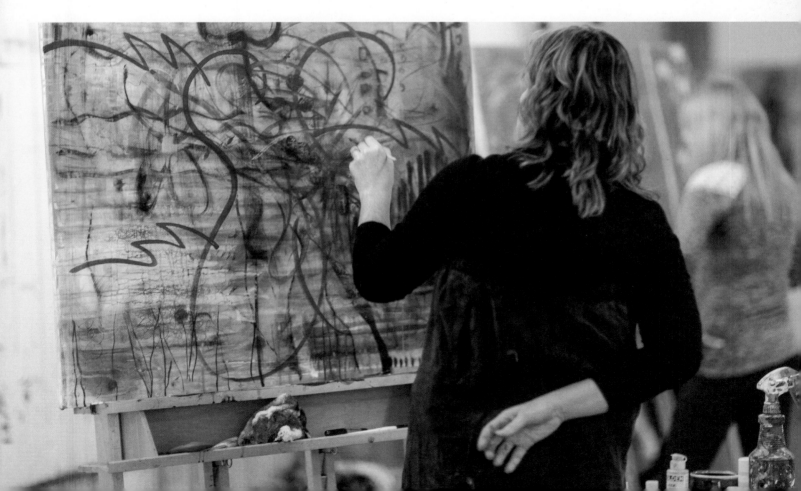

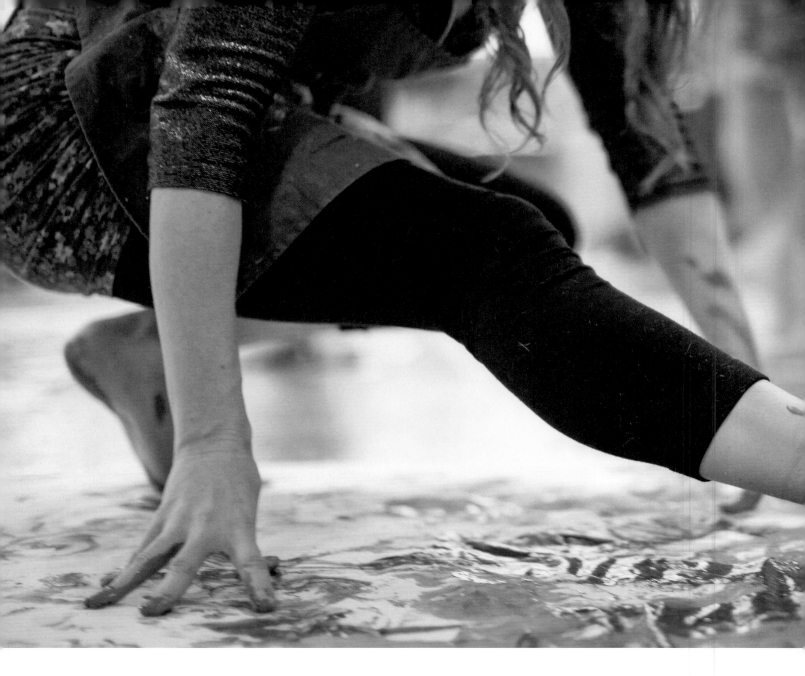

WHOLE BODY FLOOR PAINTING

Get down, move around, free up, and paint!

Imagine a painter in a studio, and you might envision an artist sitting or standing at an easel, holding a palette, studying a still life, and possibly even wearing a beret. At least this is the classic *painter-at-work* that many people envision.

There are no rules that say a painter needs to sit, stand, hold a palette, render a still life, or wear any kind of potentially unflattering headwear. In fact, expanding the way you use your body to relate to your canvas in space (and letting go of the still life altogether) can open up whole new worlds of possibility. Instead of sitting down as you paint, try standing up and getting your whole body moving.

Instead of always responding to the logic of your mind, imagine if the inspiration for your next painting came directly from your physical body's need to move through space and express itself authentically. What if you dropped your canvas (or paper in this case) onto

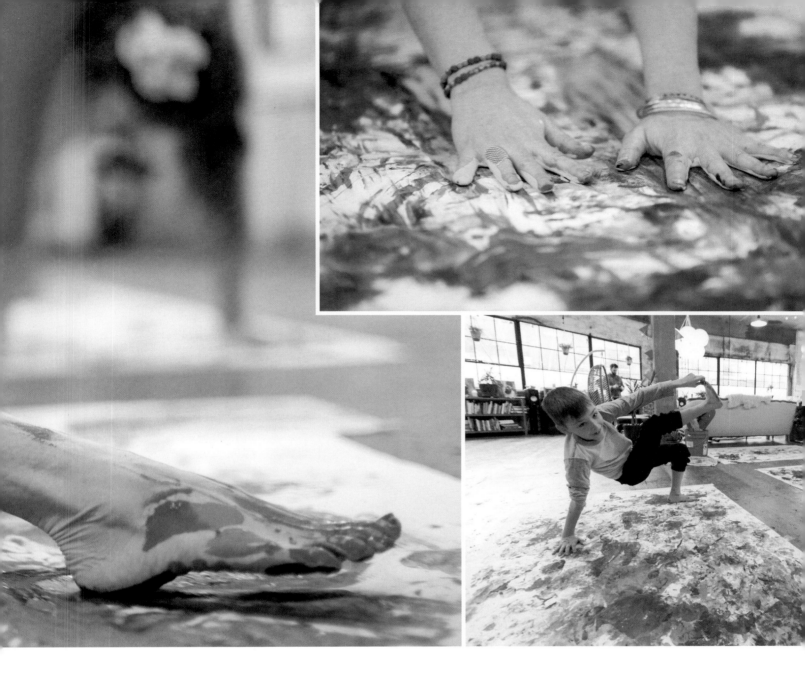

the ground and allowed gravity to be part of the equation? What if your FEET were encouraged to get in on the action?

Whole Body Floor Painting is all about using your entire body in ways that feel inspiring, expressive, and—most importantly—good to you. There is no right or wrong way to go about this as long as you follow your curiosity and allow yourself to explore what feels interesting from moment to paint-covered moment.

Your movements might end up looking like yoga poses, playful tap-dancing steps, a game of Twister, a slow and steady waltz, or a walk on the beach. We all have unique personal rhythms, gestures, and movement styles to discover, and this is a great time to let them come out and play.

Remember, the music you choose will likely have a major effect on how your body wants to move and respond, so choose your tunes accordingly. Moving in silence can also be a powerful way to experience a deep sense of awareness in your body.

MATERIALS

- Tempera paint or other nontoxic body paint
- Large craft paper, butcher paper, or pre-primed unstretched canvas
- Tape (to tape down the edges of your paper or canvas)
- Palette paper or cardboard for your paint
- A bucket of water for clean up
- Rags
- Paint clothes
- Barrier cream
- Optional: drop cloth to protect the floor
- Optional: brushes or other painting tools
- Optional: music

SETTING UP YOUR SPACE

This project can be a pretty messy process. Be sure to cover all surfaces appropriately, apply barrier cream to hands and feet, and wear clothes that you don't mind getting paint on. You might want to put a large drop cloth down on the floor and put your canvas or paper on top.

Add paint to a palette near your paper. You are welcome to divide your warm colors (reds, yellows, and oranges) from your cool colors (blues and greens) if you want to build up warm and cool layers. This will allow you to paint freely without worrying about making muddy colors.

Set up your bucket of water and rags nearby for easy clean up.

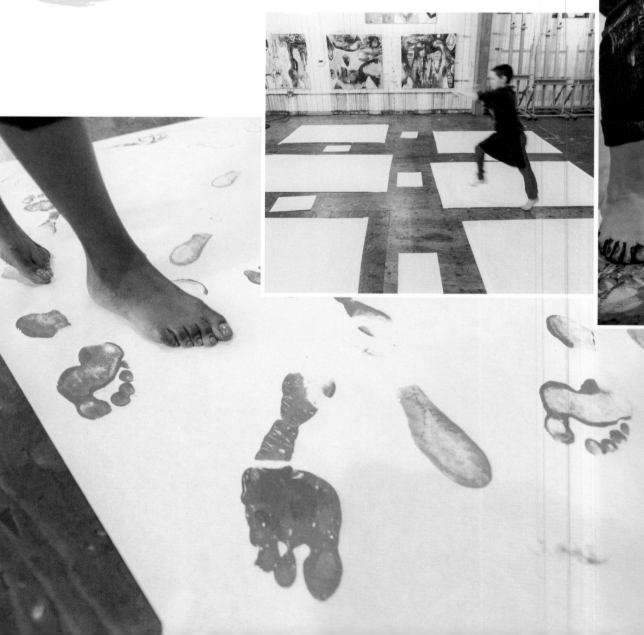

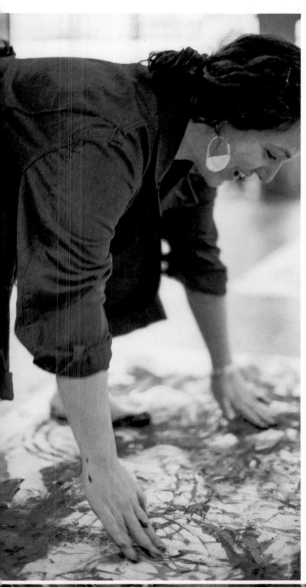

As I mentioned, there are no right or wrong ways to do this exercise. If you need a little inspiration to get your body moving, consider exploring these options:

— Dip each foot into two different colors and walk slowly across your paper.

— Explore using a light color on the ball of your foot and a dark color on the heel of your foot.

— Try sliding your feet between steps or wiggling your toes as you go.

— Explore the kinds of marks your toes can make. How about your heels?

— Drag, spin, tap and swipe the paint with the different parts of your feet.

— Try one of your favorite dance steps. What happens when you slow the movements down or speed them up?

— Grab a friend and try moving together.

— Get down on your hands and knees, and paint with your hands and feet at the same time.

— Drag, draw, tap, and swipe your fingers across the paper.

— Make stamps with your fingers, fists, the sides or backs of your hands.

— Paint with both hands at the same time.

— Try painting with your elbows. Experiment painting with other body parts.

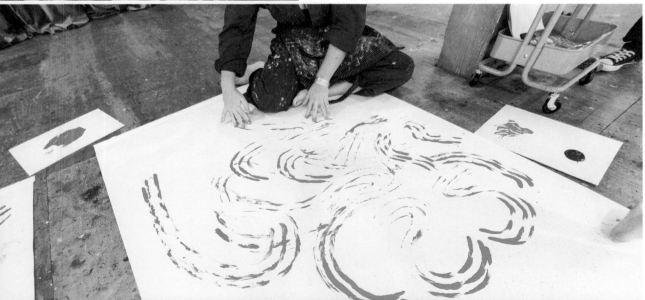

"I thought the secret of making art was learning techniques. Now I know it is about connecting with my truest self and the world around me and being brave enough to let go."

—CHERYL COOPER (BLOOM TRUE STUDENT)

EYES CLOSED FINGER PAINTING

A tried-and-true way to loosen up and let go as you paint is to remove any visual stimulation by closing your eyes, moving your body to some music, and painting with both your hands. Closing your eyes might seem rather counter-intuitive, but trust me when I say there is something powerful about not being able to see what you are doing.

Closing your eyes removes the tendency to judge your creations as they are taking shape. It also allows you to tune in to your other senses with more heightened awareness and intention. Using your fingers instead of a brush also helps to create a more direct and potent experience between you and the canvas.

Eyes Closed Finger Painting is simple. All you need is paint, canvas or paper (the bigger the better), barrier cream or gloves, a way to play music, and a willingness to get messy.

SETTING UP YOUR SPACE

Just like Whole Body Floor Painting, this can be a pretty messy process. Be sure to cover all surfaces appropriately and wear clothes that you don't mind getting paint on.

Personally, I like to hang my canvas directly on the wall. Two level screws or nails in the wall provide a great place to hang your canvas. Make sure it's at a good height for easy access.

If you're painting on paper, you'll want to use a thicker paper to absorb the paint. I prefer 140 lb watercolor or a thick bristol paper. You can use tape to adhere it to the wall.

Add paint to a palette, and have your palette near your canvas. Consider dividing your warm colors (reds, yellows, and oranges) from your cool colors (blues and greens) if you want to paint freely without worrying about making muddy colors.

Have a bucket of water and rags nearby for easy clean up.

Apply barrier cream or plastic gloves to your bare hands.

Find some music you love, and **turn it up!**

Optional: Spray your canvas with a mist of water to help the paint spread.

In my workshops, I have my students do this exercise in pairs so that one person can take care of any logistics, such as keeping the canvas on the wall and adding paint to the palette. This allows the person painting to totally let go. If you are able to find a friend to join you in this exercise, you'll probably find it to be a very bonding experience!

As you prepare to paint, let go of needing to do this "right." Release the need to know what you are doing and where this is all going. Instead, surrender to the magic of the moment.

Take a few deep breaths—move your awareness into your physical body. Bend your knees, sway your hips, and loosen any tension you are able to let go of. Shake out your shoulders, arms, and hands. Close your eyes if that's comfortable, and dip both of your hands into the paint.

At this point, let the music be your guide. Respond to the rhythms, melodies, and beats of the song. Don't hold back. Explore all the corners of your canvas and allow your movements to originate from your center, expanding outward through your arms and fingertips. Follow your curiosity and try not to peek. Keep painting for at least one whole song before you look at what you've done.

When you open your eyes, notice what your unique version of raw expression looks like? Can you see your personality and emotions in your marks? Did you discover anything brand new? How did painting with your eyes closed FEEL? Do you feel energized?

Remember, there are no mistakes. Your way is truly the right way!

MINI MOVEMENT **BREAKS**

If moving and grooving your way across a canvas with paint on your hands (or other body parts) is not exactly your cup of tea, remember that moving your body in *any way* has the power to energize, calm, reboot, and fuel your creative practice.

My pre-painting ritual involves cleaning my painting space, lighting a candle, choosing my music, and moving my body. If I'm itching to paint, I can admittedly fly through this process in a matter of minutes. Other times I move languidly, allowing the ceremonious preparation to be an equally important part of the creative process. Either way, there is movement—**always movement.**

While starting a creative practice with movement is an undeniably a great way to "arrive," taking mini breaks to move your body in the middle of a painting session is also a great way to loosen up, re-energize, and gain a new perspective. This is especially true when you are feeling frustrated, stuck, or uninspired. During these breaks, I suggest not looking at your paintings, so afterwards your mind has a chance to see them again with fresh eyes.

Winding down with easeful movements or meditation can be sweet ways of transitioning beyond your wild array of marks and colors. I suggest placing an eye pillow or piece of cloth over your eyes as a soothing way to rest your vision. Like a new mom who's just given birth, remember to move slowly and take care of yourself along the way.

CHOOSING YOUR MOVES

Remember that your awesome moves can vary just as much as your mood or color preferences. In fact, they *should* vary just as much. I believe tuning in to your body, and responding to what it's truly asking for in any given moment, is a radical form of self-care—one that we often ignore.

Instead of pushing through, forcing an agenda, or doing your same-old, same-old movement routine (or nothing at all), take a moment to check in.

Start by closing your eyes and take a few, long, deep, clearing breaths. Allow your thinking mind and swirling emotions to wind down with each passing breath. Move your awareness down into the other parts of your body as you breathe. Feel your connection with the Earth. Relax any unnecessary tension in your eyes, shoulders, stomach, hands, and feet. Then ask yourself, *"What does my body need right now?"*

Taking the time to ask your body what would feel nourishing or energizing in this moment will often yield a simple clear answer. For example, sometimes a shake-it-down-let-it-go solo dance party is in order, while other times a brisk walk around the block and some fresh air is just what the painting doctor ordered.

I often find that a couple of simple yoga poses, such as a spinal twist and a deep forward bend are exactly what my body needs to work out tension and get back in my creative groove.

And yep, sometimes my ideal movement medicine is a luxurious fifteen-minute savasana—fancy yogic term for sprawling out on my back and taking a time-out. I always did love nap time!

Remember, it really doesn't matter how you move—a few conscious breaths might totally do the trick. The point is to stay connected to something other than your overthinking, self-critical mind. Dropping into the rest of your body is a great way to do just that.

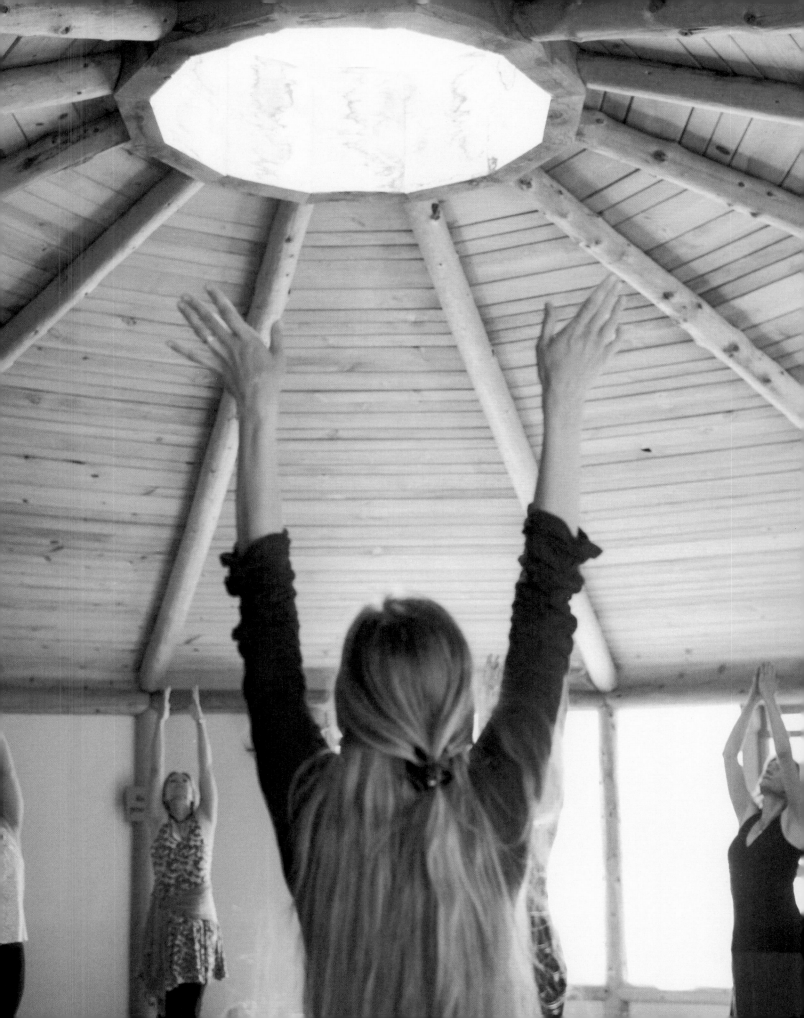

INTUITIVE **WANDERING**

Another simple way to tune in to the wisdom of your body is to practice what I call Intuitive Wandering. This fun, easy practice often leads to interesting experiences, while providing a much-needed reprieve from overly scheduled lives.

Can you remember a day when you woke up with absolutely no plan? Have you ever moved through a day listening to what the wisdom of your body wanted to do from moment to moment and allowed yourself to respond accordingly? If this feels like a lot to ask, consider starting with a simple intuitive wander near your home. It can take just a few minutes, or last all day.

The idea is simple: Let go of a plan. Release needing to know where you will go or how you will get there, and let your heart lead the way. Pause at every intersection to check in with your intuition. Close your eyes, take a deep breath, get grounded in your body by placing your hands on your belly and heart, noticing if you are feeling pulled in one direction. Go with your first flickering desire and don't look back.

Whether you call it listening to intuition, following your inner guidance, responding to an inkling, or having a sixth sense, the sensation of listening in and honoring your body's wisdom is what this practice is all about. The more you practice listening in deeply throughout your day, the easier it will be to access your intuitive voice when you step up to your canvas.

Listening to this intuitive "intelligence" is not typically taught in schools, however, deep soul wisdom does reside beyond your logical mind. Tapping into this knowing often results in more serendipity, clarity, and magical moments.

Can you make some time for an intuitive wander today?

"At any moment you have a choice that either leads you closer to your spirit or further away from it."

—THICH NHAT HAHN

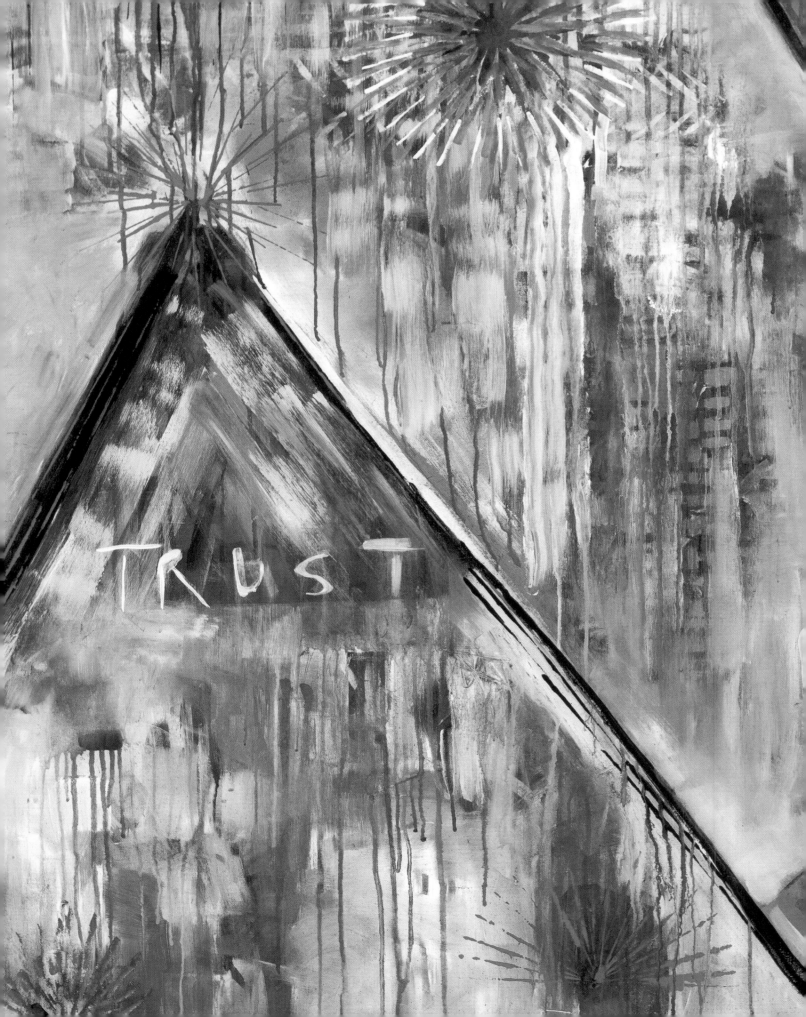

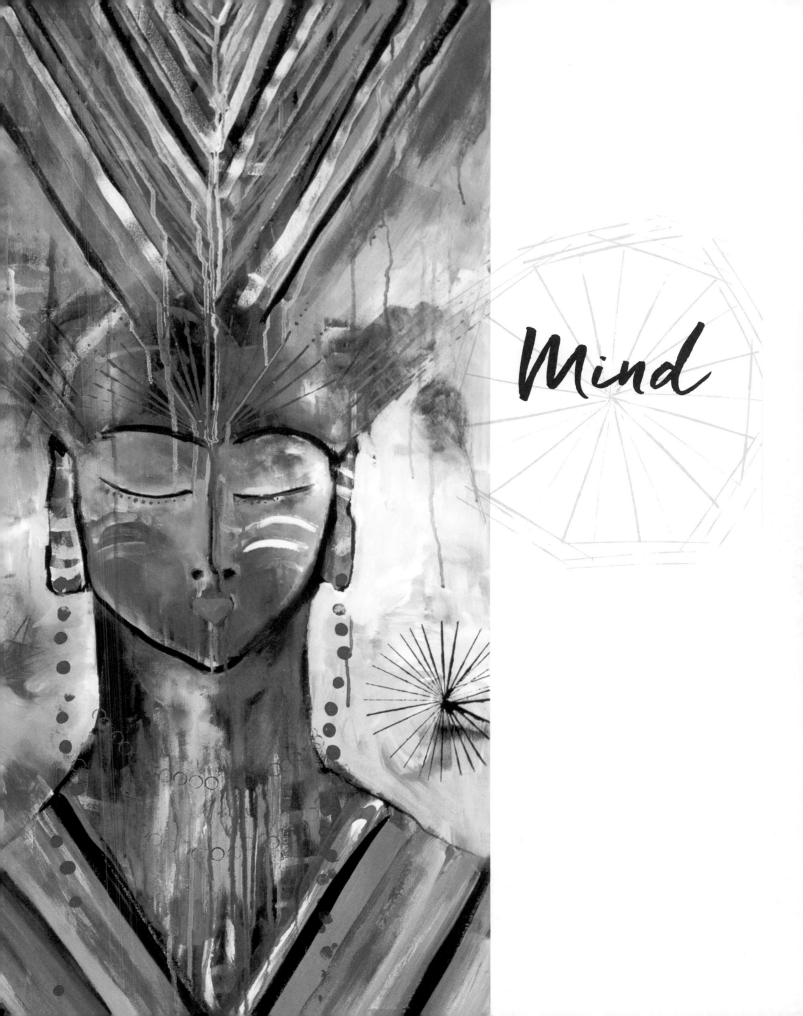

Mind

BODY MIND **INTEGRATION**

If you've wondered how our rational decision-making brain plays into this highly right-brained intuitive painting process, as in, does it play a role, or are we trying to paint entirely from a place of spontaneous, intuitive, impulsive freedom—*all the time*, this next section should help clear things up.

While brave, intuitive painting does rely heavily on an innate "knowing" that exists far beyond rational thought, it's important to understand the many vital ways your mind also supports your creative process.

From your ability to gather and process inspiration, to the fine motor skills required to hold a paintbrush in the first place, the incredible faculties of your mind play an integral role in bringing paintings to life and allowing greater access to their meaning.

For example, a wild brushstroke created to the beat of a drum or with your non-dominant hand might allow you to get those loose unexpected lines your rational mind is craving. That same untethered energy may also become an important element as your composition-hungry mind works to intentionally balance out your painting later on.

Understanding and embracing this relationship between intuitively letting go and making more conscious decisions allows the painting process to become a dance where all forms of intelligence are invited and honored.

Can you imagine how interesting things become when the wisdom of our intuition, body, and mind start to intersect, overlap and inform each other?

Ultimately, the key to integrating your mind into this intuitive process is by honoring your thoughts and ideas as valuable information and being willing to "try them out," while simultaneously staying open to change.

For example, if adding a face or using a lot of blue feels intriguing, then go for it! Just remember to stay open to change—the moment you lock into things *needing* to work or be a certain way is the moment possibility and freedom walk out the door.

Whether your impulse to add black lines comes straight from your heart or from your intellectual desire to add value contrast, remember all your wisdom is valuable because it comes from you.

This, my friends, is the beauty of working in layers with acrylic paint. You can explore many ideas, change your mind, try on new ideas, and continue exploring until something starts to truly take hold.

"Creativity is intelligence having fun."

—ALBERT EINSTEIN

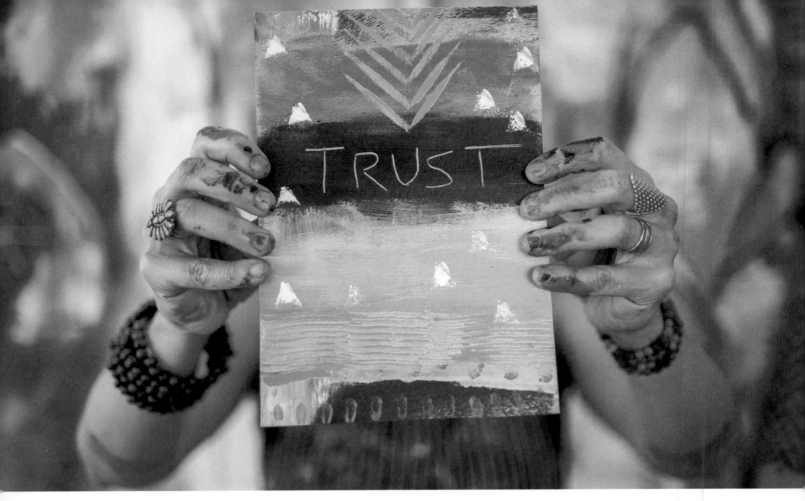

CREATING A PERSONAL AFFIRMATION DECK

I think it's safe to say that our minds have some pretty crafty ways of getting in our way and keeping us from exploring our creativity with a sense of freedom and play. Somewhere along the line, we decide we're not good at "art" and the rest is history.

Before we dive into all the wonderful ways that engaging our minds can *serve* our painting practice, I want offer a simple exercise to clarify what kinds of thoughts and information we want to keep at the forefront of our experience.

Re-examining how we talk to ourselves is a vital step to unlocking our creative power. Creating an affirmation deck is simple, fun, and results in a sweet and portable deck of inspiration to have in the studio or take on the road.

This exercise is all about consciously choosing the messages you want to send yourself through the words you write, say, read, and think. Affirmations are wonderful tools to draw us out of old stories, shake our foundation (in a good way), and make space for new patterns to emerge.

These declarations can be any words that inspire, remind, evoke, or encourage you to return to our soul's deeper longings. They can be declarations, simple words, bits of poetry, or ideas you want to remember. If it moves you and feels true to you, it's an affirmation.

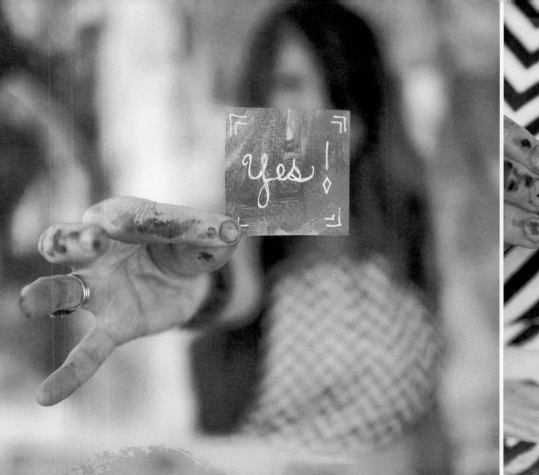

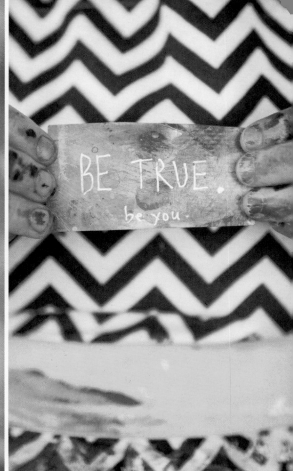

MATERIALS

- Thick paper, such as 140 lb watercolor paper or cardstock
- Scissors
- Acrylic or watercolor paints
- Brushes
- Optional: markers or pens

1. To create your deck, simply cut up watercolor paper or cardstock in any size that works for you, and add color as you are moved—there are no mistakes! Use paint pens, markers, or a small paintbrush to add your words. Affirmation cards can be as elaborate or as simple as you wish.

2. When you're finished, consider posting your affirmations in places where you'll see them regularly. Speaking them out loud is another awesome way to give your words staying power.

AFFIRMATION
DECK IDEAS

ALLOW
BE BRAVE
TRUST
NOURISH
BE TRUE
BABY STEPS
EXPAND
GIVE THANKS
BREATHE
YES!

EXPANDING YOUR VISUAL LANGUAGE

Stepping up to a blank canvas with no idea where you are going can be absolutely thrilling, but it can also be terrifying. What happens when the magic is nowhere to be found and you start to paint yourself into a corner?

This is where the mind's ability to gather and archive inspiration before stepping up to the canvas comes in handy. One of the most important jobs of any artist is to move through life with the attitude of an explorer—always collecting new experiences, shapes, symbols, colors, and ideas and storing them away for future reference.

I call this ever-expanding repertoire your Visual Language.

Seeking, finding, and redefining this language is a crucial part of any artist's path. Ask yourself, *"What's important to me? What is it that I want to convey, and how can I say this through the language of paint?"*

The gems you collect from the world around you may or may not make their way into your creations, but the point is to show up with an abundant treasure chest of inspiring options. If you end up being swept away by the magic of the moment, great! If not, your box of jewels will be waiting patiently to rescue you from your creative doldrums.

If you choose to see through the lens of an artist who is always hungry for inspiration and ideas, you get to witness life in a completely new and turned-on way. The ordinary becomes extraordinary, and the simplest moments are brought into focus with a lightning bolt of inspiration. Even in the most mundane circumstances, there are worlds to discover if you take the time to notice.

Imagine how a simple stroll down the sidewalk can turn into a treasure hunt for new shapes and imagery, or how meeting a stranger can open doors to incredible new worlds. Even life's greatest challenges have the power to add unexpected layers of depth to your visual stories if you're open to seeing them this way.

Expanding your Visual Language is a wonderful, ongoing process that happens over time. It can happen organically, but it can also be a very thoughtful and conscious process. One of my favorite ways of collecting inspiring gems is by slowing down and photographing the world around me.

CAN YOU FIND?. . .

SHADOW + LIGHT

MOVEMENT

PARALLEL LINES

CIRCLES

A REPEATING PATTERN

A HUMAN FIGURE

COMPLEMENTARY COLORS

COLORS YOU LOVE

THE VIEW ABOVE

THE VIEW BELOW

INTERESTING SHAPES

ARCHITECTURAL ELEMENTS

NATURAL FORMS

NEGATIVE SPACE

A VARIETY OF TEXTURE

PHOTO SCAVENGER **HUNT**

Wherever you are, start by closing your eyes and taking a few deep breaths to become more present. When you open your eyes, imagine that you are seeing this place for the very first time with the eyes of a child—full of awe and wonder.

Notice the colors and shapes that immediately draw your attention and move towards them for a closer look. Shift your perspective, get comfy and allow yourself to engage all of your senses. This is a wonderful opportunity to pause, reflect, and soak up the world around you.

EXPLORING COLOR

Pay particular attention to the way different hues react next to one another. Typically, colors that live across from each other on the color wheel (complementary colors) create a visual spark when they find themselves next to each other. This kind of contrast is a common occurrence in nature. Can you find examples of this in your environment? Look for these combos: red and green, blue and orange, yellow and violet.

Another form of color contrast occurs when soft hues meet vibrant colors. Imagine bright yellow leaves against the backdrop of a moody grey sky, or bold fuscia lining the edge of a pale pink rose petal.

Color combinations can be wildly spectacular or quietly subtle. There is no right or wrong color scheme. What's most important is to honor what feels interesting to you. When you've discovered a marriage of color that really lights you up, snap a photo for future reference.

EXPLORING SHAPE + TEXTURE

The world is also full of a diverse array of shapes and textures to discover. Personally, I find naturally occurring shapes in nature much more interesting than my preconceived ideas of form. For example, the flowers I see on my neighborhood walks have much more personality than the flowers I draw from my minds' eye. This is why taking a photo of interesting forms can really bring your paintings to life.

When it comes to textures, notice the different surfaces observed through your lens. Can you find something soft, coarse, prickly, or fuzzy? Consider taking a closer look. You might be surprised by what you see and who you meet!

EXPLORING LIGHT + SHADOW

Light and shadow are ever changing and photography offers a way to truly see and capture these daily fluctuations. By noticing value contrast in the world around you, incorporating light and dark can become a more naturally dynamic part of your painting process. Remember, it's the relationship between light and shadow that defines the shape of everything we see.

The photographer for this book, Zipporah Lomax, delights in spending countless hours photographing the intricate details of the world around her. The way she captures color and light is simply stunning!

MORE WAYS TO **GATHER** SEEDS OF INSPIRATION

Keep a sketchbook. Artists have always carried sketchbooks to record the world in their unique way. In this digital age, slowing down to draw is especially important. I also believe that drawing from life gives LIFE to your drawings. Remember, your sketches can be loose interpretations of what you're seeing. They don't have to be perfect in any way. Simply jot down shapes, images, and patterns that feel interesting to you. You never know how they might make their way into a painting.

Take photographs. One of the benefits of often having a phone/camera in your pocket is the ability to record the colors, shapes, and inspiration you observe with just the tap of a button. Can you find patterns, shadow, light, organic shapes, human forms, and architectural detail in the world around you? Maybe a selfie will inspire a self-portrait? Remember to look up, down, and all around—inspiration is everywhere.

Write it out. Reflecting on what makes you *you* is a wonderful way to come up with new ideas to explore in your painting. Here are some great questions to consider: *What inspires you on a daily basis? Where to you love to travel and why? If you had a special altar, what items would you keep there? What are some of your favorite colors? How do your friends describe you? What lights you up? What brings you joy? What instills peace?*

Collect objects. Have you ever found a special feather, rock, or bit of fabric, and thought, *"This would be a great shape or pattern to incorporate in my art."* If it's appropriate, bring it home. If you need to leave it, take a photo or make a sketch.

Take a trip to the library or bookstore. Browse through any section that calls to your heart, and be sure to broaden your scope of inspiration beyond art books. Consider flipping through a book about exploring the cosmos, or a guide to local plants from your region. Could a dramatic historical tale make its way into your creation? How about expanding your repertoire of shapes with a book about sacred geometry? There is so much inspiration waiting to be discovered within the pages of books. Once you start perusing, it might be hard to stop.

Look at other artists' work. This age-old tradition of finding inspiration from other artists is a tried-and-true way to get ideas and spark new directions in your work. If you're first starting out and trying on many new things, you might try to copy other artists' work. However, when you start to share or sell your work, it's very important that your style is true to you and not simply copied from another artist.

The absolute best way to avoid this unsavory territory is to ask yourself, very specifically, what it is you enjoy about another artist's work. Maybe it's their use of color, an image they use, or the way they pile on thick paint. It's perfectly fine to explore aspects of another's work in your own, but it's extremely important to incorporate the information in a way that is unique to you.

Experiment with new tools, or use your current tools in new ways. Sometimes finding a new tool can kick-start a whole new series of paintings. A couple of years ago, I discovered that potatoes can create different stamping shapes. My paintings changed drastically. *What unexpected tools might be lingering in your cupboards or backyard? How can you use your current tools in new ways?*

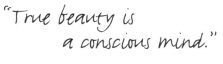

"True beauty is a conscious mind."

—MARINA ABRAMOVIC

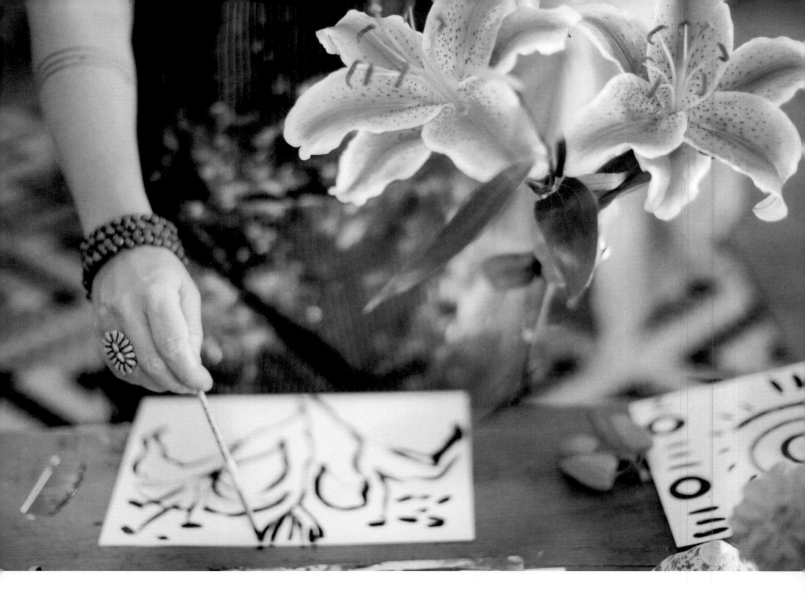

INSPIRATION **ARCHIVING**

For many people, finding inspiration in the world is not the problem. You might be easily delighted by the way the sun hits the trees or by the explosion of pattern and color you find in a rug store. Perhaps you collect bits of nature and sketch on every napkin you find, because you're just so—darn—inspired!

Keeping track of all these bits of inspiration so they might have a chance of making their way into your paintings someday is what I call Inspiration Archiving. Just like the many other details in your life, inspiration thrives with a bit of organizing thoughtful.

If you don't already have piles of inspiration laying around, start seeking it out through the Gathering Seeds exercises. Once you have amassed a collection, it's time to archive for easy access.

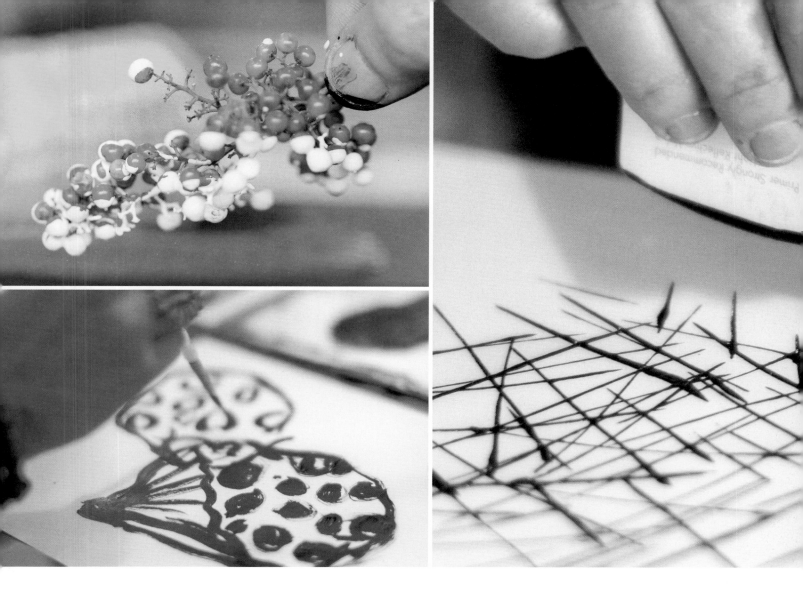

MATERIALS

- White typing paper or card stock (feel free to save paper by working on the back of old papers)
- A black marker or fluid black paint
- A small pointed paintbrush (if you choose to use paint)

— On each piece of paper, loosely draw the image or shape you would like to archive. Don't worry about making things look perfect. In fact, loose drawings can morph into other shapes more easily, so that's great!

— You can also focus on particular details or things that jump out from your original sources of inspiration. For example, if you took a photo of a field of daisies, you might archive one or two flowers to reference later.

— Also consider archiving the way your painting tools make different marks. Explore your tools in new ways—use the edge, stamp a corner, drag it sideways, slow it down, or cut it up.

COLOR **CRAVING**

Another way to build your repertoire of inspiration and fill your toolbox with ideas that are easy to access when you need them, is by building a personal color library. Instead of focusing on technical and potentially overwhelming rules about color theory, let's allow our individual preferences and intuition lead the way.

Ultimately, choosing color is very personal territory. All you have to do is look in someone's closet or living room to see we all have different tastes when it comes to color. This Color Craving exercise is all about simplifying the world of color, while clarifying and embracing your own personal color aesthetics.

The idea is simple. Start by painting one swatch of color on your paper or canvas, then ask yourself, *"What color am I craving next to this color?"* Let go of rules and overthinking, and go with your gut. Trust your first inclination. Mix up the color you are craving, or use a color straight from the tube. Add a swatch of this second color next to the first, and then ask yourself, *"What color am I craving now?"*

Continue adding colors in this way for as long as you feel inspired. A simple palette might consist of only three colors, but you are welcome to add as many as you'd like.

When you're feeling complete, consider adding more of one color to bring the palette together. For example, if your palette consists of teal, orange, pink, and green, you might choose to add more teal in various places around the paper to help unify the other colors.

Voilà—you've just developed a new color palette, while creating a mini abstract painting along the way!

Keep your "cravings" in a book or pin them to your wall. They might come in handy the next time you're deciding what color to add to your painting.

"The best color in the whole world is the one that looks good on you."
—COCO CHANEL

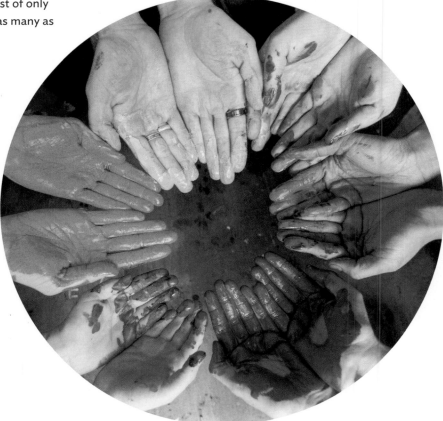

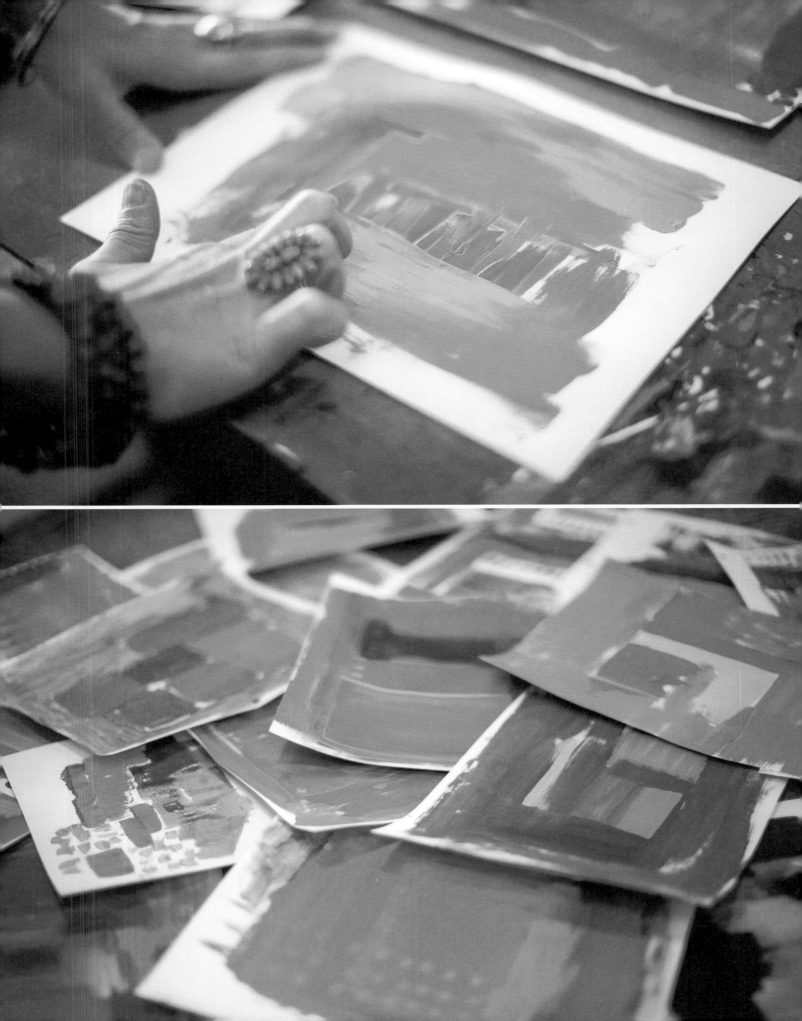

CONTRAST IS CRUCIAL

You've probably heard the old adage, "opposites attract." Maybe you've even experienced this compelling phenomenon in a relationship. The truth of the matter is, contrast adds spice.

Whether we're talking about relationships, daily routines, the food we eat, or the colors we paint with, mixing things up and getting out of our habitual patterns can be a powerful way to wake up our senses and fan the flames of inspiration.

Contrast certainly makes life more interesting. When it comes to painting and living a creative life, I believe contrast is *crucial*.

Incorporating contrasting elements into your paintings creates more visual vitality. The push and pull between dark and light, warm and cool, broad and detailed, opaque and translucent—all have incredible power to add depth, variation, and straight up pizzazz.

I often see new painters using the same tools in the same way, over and over, and this makes perfect sense. They're dipping their toe in the proverbial paint (so to speak) to find out what feels comfortable. Learning by doing is a powerful way to truly absorb the lessons.

For example, making circles with a brush or small dots with your fingers might feel comfortable, and the color teal might be your go-to favorite. Again, no problem when you're starting. You are simply expanding your painting vocabulary one circle and teal dot at a time.

Eventually broadening your skillset becomes a crucial part of developing your unique voice as an artist. When you're aware and open to this kind of artistic expansion and growth, it often happens quite naturally—especially when you're willing to experiment.

EXAMPLES OF CONTRAST

— Value: Value refers to the scale from light to dark. Try starting with a very dark value and add a very light value in the next layer to create an exciting pop.

— Color: There are many ways to work with contrasting colors. Complementary color pairs such as blue and orange, yellow and violet, or red and green create dynamic spark when layered. You can also explore the contrast of muted colors next to bright colors.

— Size: Varying the size of your marks, images or brushstrokes creates dynamic contrast in your composition.

— Energy: Explore different energies such as "wild," "dainty," "staccato," and "languid" to create interesting juxtapositions on your canvas.

— Shape: Exploring different kinds of shapes is another great way to bring unexpected contrast into your painting. Try playing with organic, angular, curvy, and geometric designs.

— Opacity: Every color and brand of paint will vary in its translucency. Some colors are quite opaque (meaning you can't see through them), while others are very transparent. Experiment using both kinds of paint to spice up your layering process.

— Texture: Consider building up thick texture right alongside thin areas of paint to create compelling textural contrast.

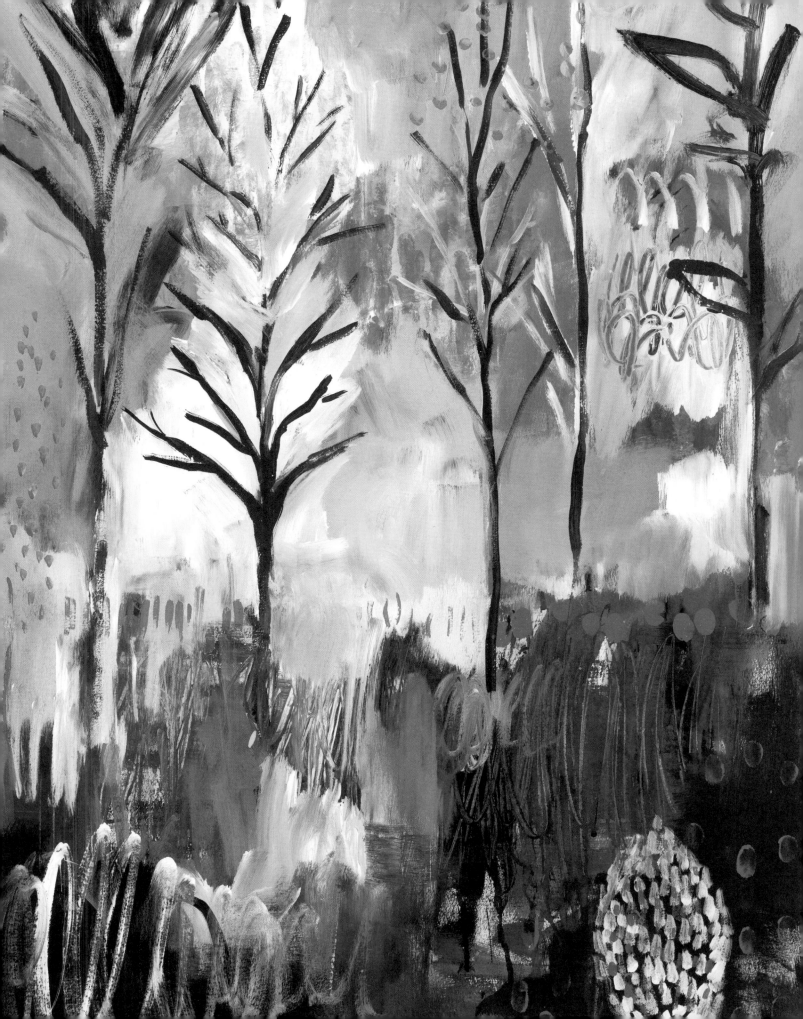

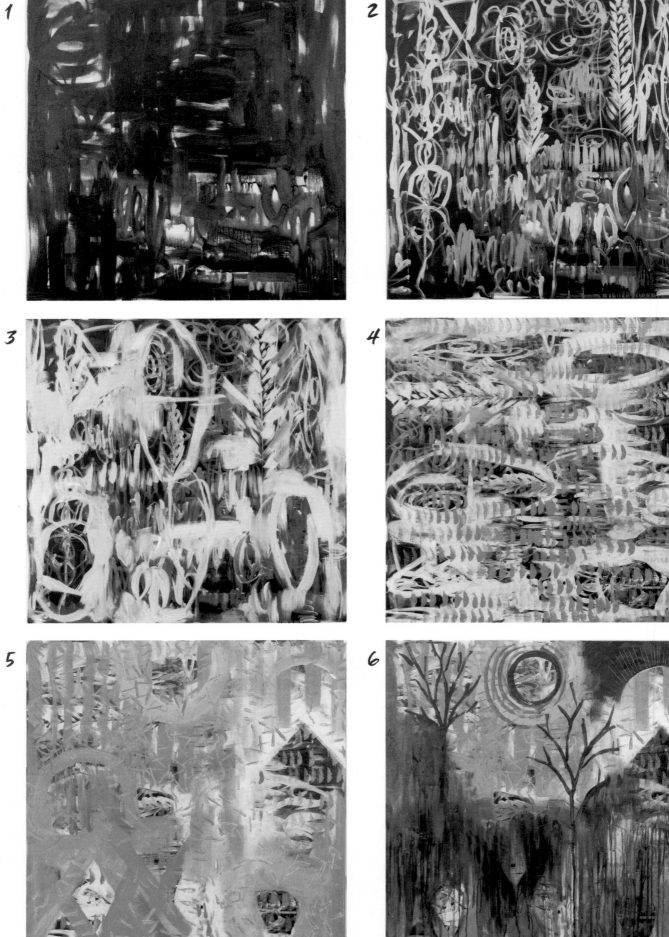

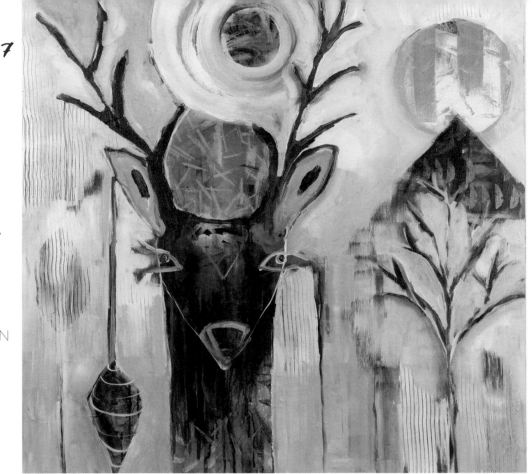

7

"Every moment of
light and dark
is a miracle."

—WALT WHITMAN

LAYERING WITH CONTRAST

One great way to introduce dynamic elements into your painting is to incorporate different types of contrast as you build up layers.

MATERIALS

- Canvas, panel, or paper. You will need a minimum of two surfaces to paint on so your layers have time to dry.

- A basic set of acrylic paints, including black and white

- A variety of brushes in different sizes and shapes

- A water jar

- Rags

- Optional: other mark-making tools

HOW IT WORKS

There are no rules or specific guidelines in this exercise. The goal is to simply respond to whatever you've done in the previous layer by using some kind of contrasting element in the next layer.

You can cover up or leave as much of the previous layer as you'd like—this will likely vary from layer to layer. It's important that each layer is dry before you add the next layer to avoid muddy colors. You are also welcome and encouraged to turn your canvas in new directions if that feels interesting in any given moment.

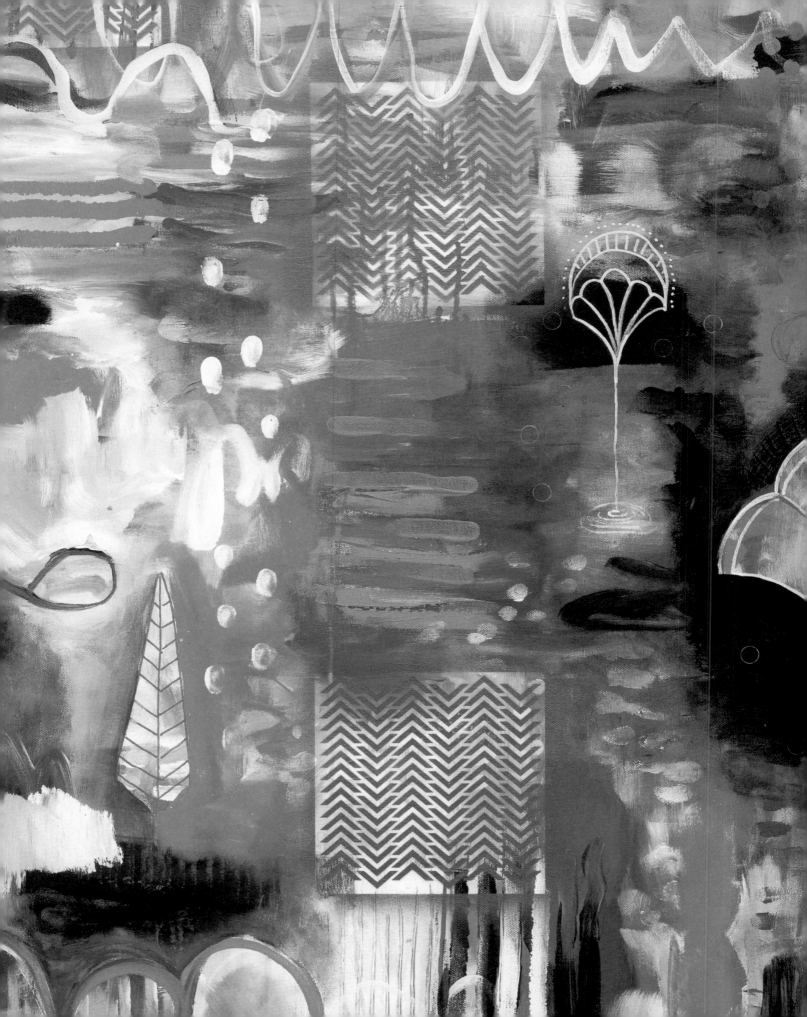

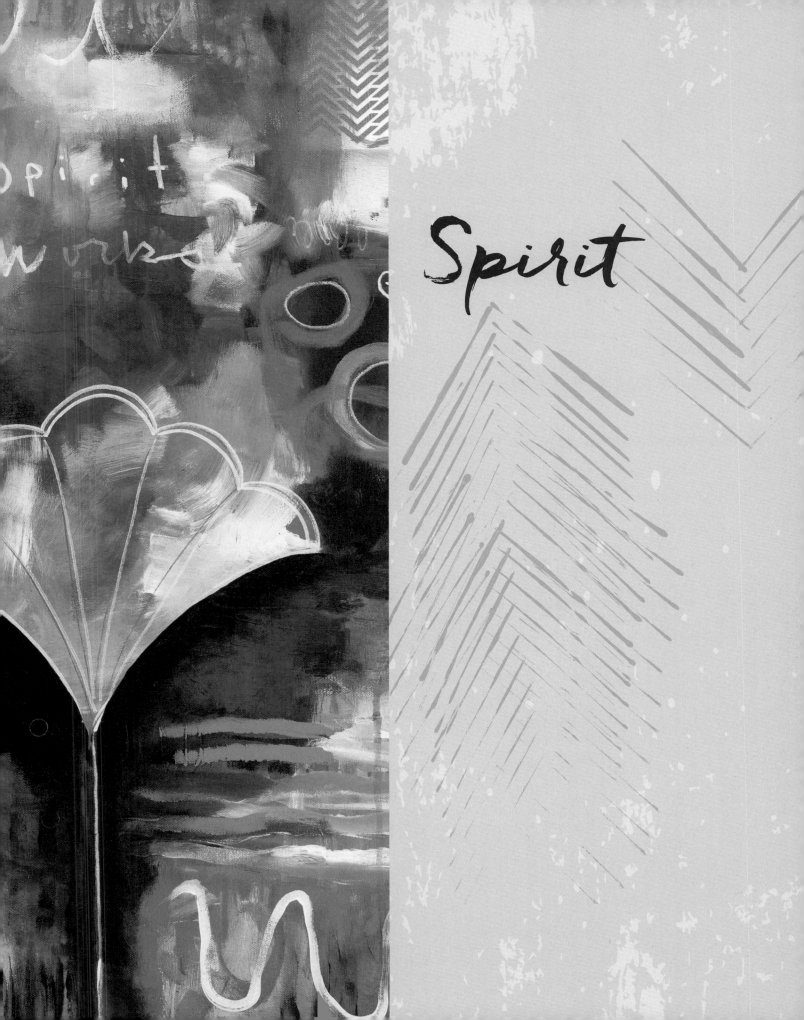

Spirit

SPIRIT IN **MOTION**

In the Body and Mind sections of this book, we explored some of the ways our physical bodies and intellectual faculties can influence and inspire our creative journeys. Now it's time to dive into another great arena of sacred mystery and sublime wisdom: Spirit.

Writing about the connection between spirit and creativity feels a bit like trying to explain a deep mystical journey between two lovers. They come together to dance, inspire, challenge, provoke, and ultimately lift each other upwards. Their connection runs so deep, some might say they are essentially the same thing or two sides to the same coin.

I like to think of creativity as spirit in motion.

Regardless of definitions, I think it's safe to say that we each have our own unique relationship with spirituality and this speaks volumes about the great mystery itself.

For many, spirit is intrinsically connected to a specific religion, while others subscribe to a more universal understanding. Earth-based forms of spirituality can also play a large role, while some people are quite content in the "un-knowing."

While humans seek many different ways to make sense of the world, the creative process offers a vehicle to explore self-discovery in a beautifully universal and tangible way. The act of creating something out of nothing, whether it's a painting, poetry, or any other form of expression, gives us a chance to make the invisible visible, while potentially learning potent life lessons.

Whether you call it inspiration, the muse, God, consciousness, or simply flow, this relationship to something greater than ourselves invites a sense of curiosity and wonder. It also offers the much-needed gifts of presence, playfulness, growth, and connection.

To give you a sense of my own relationship with spirit, we'll have to go back to Green Bay, Wisconsin, where I was born.

I grew up in a Midwestern household and attended a Congregational church every Sunday. While my family was open and progressive, I used to think "sacred" or "spiritual" needed to *look* a certain way—like this seemingly elusive way of experiencing the world was something that could only happen in a church, on a meditation cushion, or in the presence of an enlightened being.

In other words, I used to think there were rules.

Despite my limited understanding of what living a sacred or spiritual life actually meant growing up, I knew my craving for this kind of meaningful connection ran deep. Even as a young kid, I had no interest in simply going through the motions of day-to-day life. I craved a sense of belonging. I wanted to experience the world in a profound, authentic, and connected way— I wanted to feel passionately alive. As a child, I found this feeling through nature, art, and moving my body.

"To me, looking into a painting made with the intuitive process is like looking into the world of spirit. Pure magic."
—RACHEL LEIGH HUDSON
(BLOOM TRUE STUDENT)

"Do not seek the Because. In love there is no because, no explanation, no solutions."

-ANAIS NIN

FINDING MY WAY

As I grew older, I continued to follow my heart toward this feeling of aliveness, and this insatiable appetite brought me to some very interesting places. I traveled all over the world, volunteered in disaster zones, joined a sustainable farming collective, made annual pilgrimages to Burning Man, tried my hand at off-the-grid living, and backpacked hundreds of miles through remote wilderness areas.

I learned how to track wolves and start fires with sticks, devoured every self-help book I could get my hands on, and became a yoga teacher and massage therapist. I raved till the sun came up, sweated my heart out in Lakota sweat lodge ceremonies, sat with Peruvian shamans in the Amazon, attended ten-day silent Vipassanā meditation retreats, and tried out a raw vegan diet.

And yes . . . I joined a circus.

Throughout these years of soul searching, two things remained constant in my life—my passion for making art and my passion for seeking truth. I created hundreds of paintings during this time, while simultaneously dedicating myself to a path of personal healing, self-growth, and service.

With each finished painting and each life experience, I became more at peace from the inside out. I began to understand that living life as a spiritual practice was simply a matter of perspective and choice, and, with this understanding, absolutely *anything* could be sacred.

This seemed especially true when it came to making art.

By choosing to live in a world where deep mystical connections are alive and well, intuition is considered valuable information, and love is the guiding light, I was able to easefully infuse my artwork with these values and beliefs. Over time, my creative practice became a natural extension of my spiritual practice, and it continues to serve this purpose for me today. *In fact, it's really hard to imagine one without the other.*

THE PRACTICE

So, what does living a spiritual life actually *look* like? How can we infuse our everyday life with more meaning and connection, and how can we weave these practices into our creative lives?

There are certainly no rules for how to invite a deeper connection into our lives or into art-making experiences. In fact, that is one of the many blessings I've discovered by exploring so many different paths. There simply is no right or wrong way, as long as your outward actions resonate with your innermost desires and beliefs.

I've learned that it does not have to be fancy or complicated, or need to happen in a church, on a meditation cushion, in the presence of an enlightened being, or on a mountaintop for that matter.

Subtle shifts in perspective and simple intentional acts have the power to make impactful and lasting change.

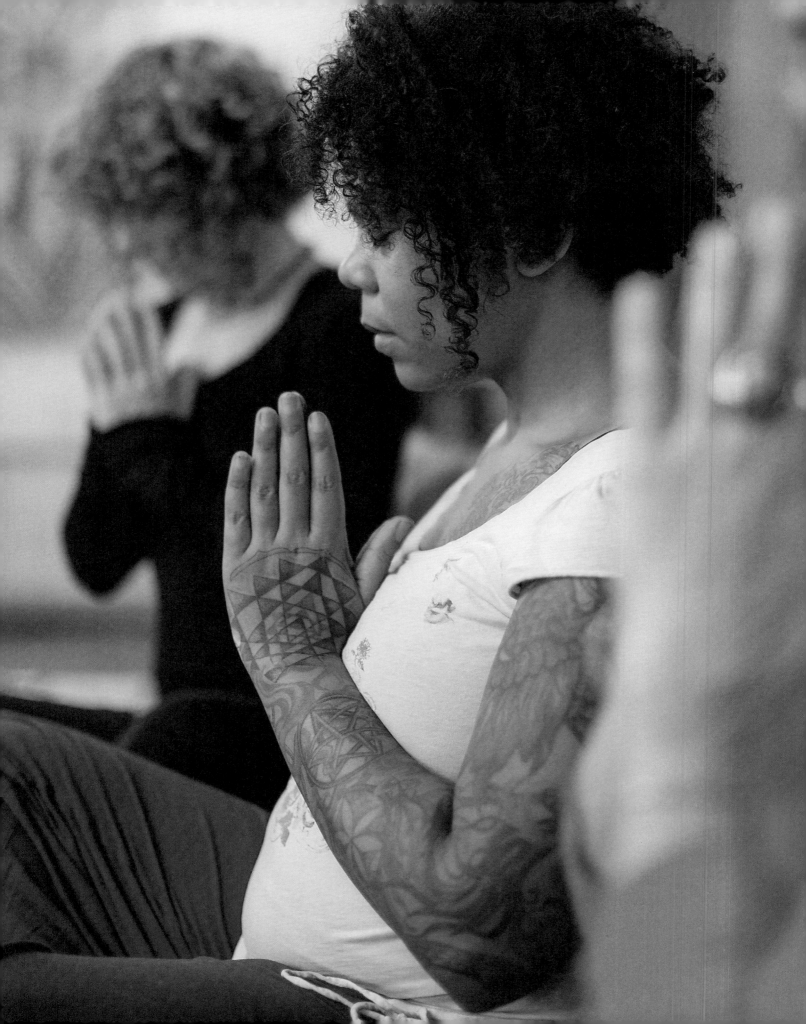

GETTING **QUIET**

People often aske me, *"How do I access my intuition?"* My simplest answer is this: The more you can quiet your mind, the clearer your intuition will become.

The age-old practice of meditation is becoming more and more popular these days, and for good reason. In our increasingly busy world, it is vital to take time out to simply BE with yourself—quietly and consciously. This might look like sitting in meditation, walking slowly through the woods, or even doing the dishes with a sense of mindfulness.

There are infinite ways to practice quieting the mind. The important thing is to actually show up for yourself.

If you are new to meditating, try not to get caught up in the specifics of how, when, where, and why you are *supposed* to meditate. These pressures will likely get in your way. Instead, keep it simple.

Close your eyes whenever and wherever you can find the time and space, and simply take a few deep breaths. This might happen right when you wake up in the morning, standing in line at the grocery store, or before you eat a meal. It could happen right now!

Personally, I love doing short and sweet meditations in the morning, prior to diving into my painting sessions, and as I fall asleep at night.

Obviously, longer and more in-depth meditation practices are great, so by all means explore what you feel drawn to. Just remember, taking these precious moments for yourself is a crucial part of your well-being, and a potent way to quiet your mind and connect more clearly to your intuition.

"The quieter you become, the more you are able to hear." —RUMI

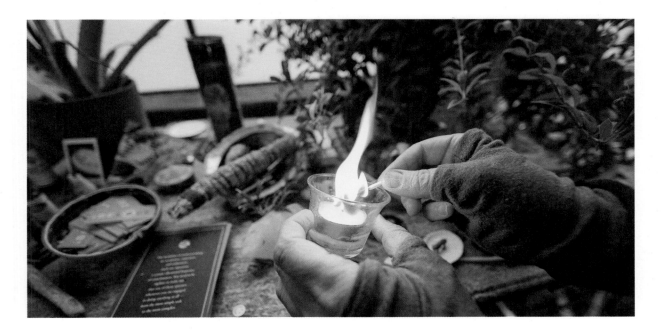

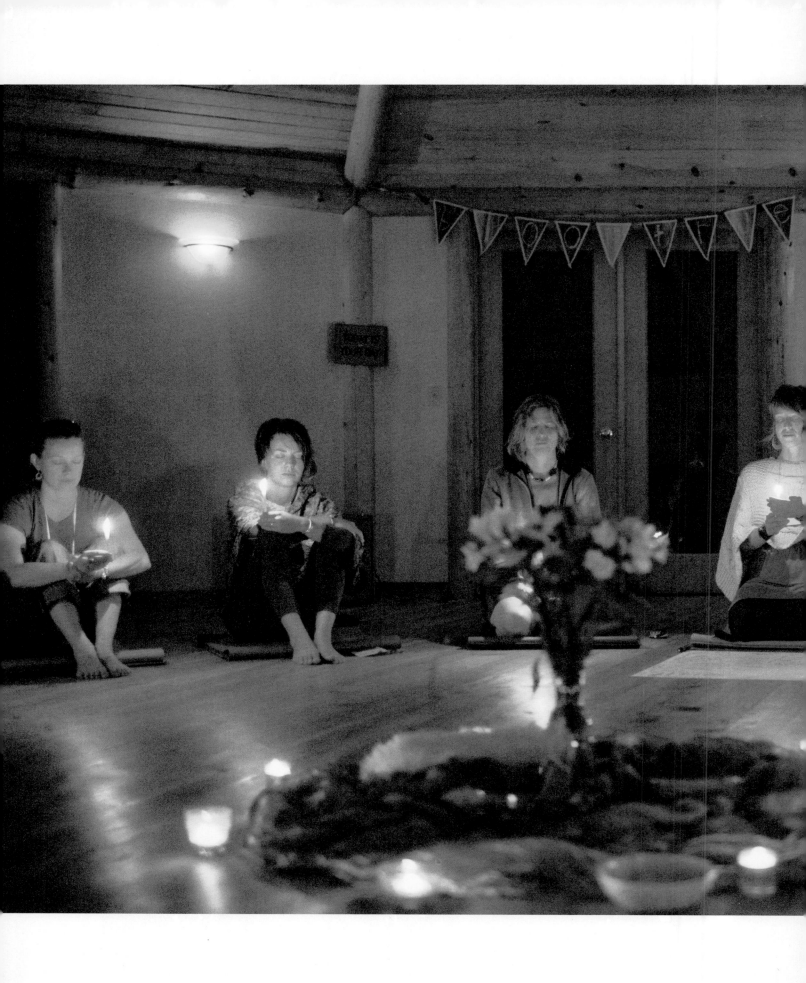

SETTING **INTENTIONS**

I wholeheartedly trust the power of intention.

The act of setting intentions provides an opportunity to connect more deeply with your soul's calling, to clarify your core desires, and to open your heart and mind to the infinite possibilities that are available to you every day.

I imagine the doors of opportunities wildly swinging open as clear intentions are being set. In this way, intentions are like magnets; the more you declare, believe, and act in ways to manifest them, the more powerful and real they become.

By setting intentions—you align yourself in the direction you want to move. From this place of clarity, your ability to recognize circumstances that support your core desires becomes more and more obvious, and new opportunities often present themselves.

Clarifying your intentions before you dive into your creative process can be an incredibly profound act. I think of it as setting the stage, asking for what you want, and opening the channels for inspiration to flow through.

Take a few minutes today to set some intentions and make some commitments for yourself and your creative practice. Write them down (or paint them), and place them where you will see them often. Sharing your intentions with your friends and family members also strengthens their power.

Finally, remember to give thanks when you find yourself walking through those doors of opportunity that swung open as a result of your intention-setting. This recognition reinforces the intention feedback loop, creating even more abundance in your life!

CREATING A PERSONAL **ALTAR**

Across the globe, many cultures use an altar as places of prayer, contemplation, and intention setting.

I've always enjoyed setting up altars in my home and in my creative spaces to display and appreciate meaningful items in my life.

Having a physical place to gather up this kind of cherished memorabilia creates a visual reminder to connect with the deeper reasons you are drawn to create in the first place. They also provide a perfect place to take a few deep breaths, light a candle, and create an intention before you start to paint.

Altars can be simple or elaborate, and they can consist of anything that holds true meaning for you. My altars usually contain bits of nature that I've collected, words of inspiration, crystals, pictures, plants, and candles. Altars are also a great place to put your affirmation cards.

There are no rules for how to make an altar. The most important thing is for you to feel personally connected and at peace when you experience your altar.

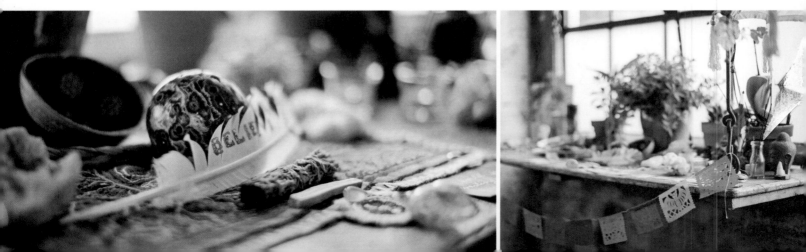

ALTAR LOVE

— Create your altar in a place where you will see it regularly.

— Choose a place that is safe and protected from swinging dog tails, curious toddlers, gusts of wind, and any other potentially disruptive forces.

— Consider using a piece of fabric that you love as the foundation for your altar.

— Use boxes or books to add height and dimension. You can also cover these with fabric if you choose.

— Incorporate the elements of fire, water, earth, and air.

— Display pictures of the people and animals you love.

— Add words of affirmation, intentions, tarot or angel cards, personal letters, and notes.

— Thoughtfully arrange meaningful objects, memorabilia, and items from nature in a way that is pleasing to your eye.

— Have sage, palo santo, or incense available to burn. This is a great way to clean stagnant energy, invite your intentions, and stimulate your sense of smell.

— Add candles so you can activate your altar.

— Keep your altar clean and cared for. Consider rebuilding it each season or during big times of change.

— Put together a "travel altar" and take your altar on the road!

EMBRACING THE **MYSTERY**

If you're wondering how your connection with spirit might play a direct role in your painting process, this next section will shed some light on the topic.

Let's start with a conversation about mystery. While it's an incredibly natural human tendency to crave a plan and a sense of knowing where you are going next, having these preconceived ideas or goals cemented in your mind often sets you up for some degree of inevitable frustration in the creative process—and in life.

If your creations fall short of your original, fabulous ideas, you can be left feeling blocked and disappointed in your efforts. In the worst-case scenario, you might quit and never look back.

So, how do you create with no map of where you are going? How do you get from blank canvas to finished painting without a plan? Creating in this kind of ambiguous territory can present some definitive challenges, but opening yourself up to the unknown can also be invigorating and deeply revealing.

A few years back, I painted the words, *Embrace the mystery* right on the wall above my canvas. It happened in a moment of frustration—one where planning, forcing, and needing to know where it was all going was getting in the way of my natural flow.

Even after twenty-plus years of intuitive painting, this still happens to me all the time. It's such a naturally human tendency to want to plan and plot. However, the more you flex your brave intuitive muscles, the easier letting go becomes.

These words continue to remind me to surrender my agenda, follow my curiosity, and remain open to all possibilities in all moments. Painting from this place is not always easy, but it is exactly what makes my paintings (and my life) come alive in ways I could never predict. These are the moments that keep me coming back for more.

"Fear is a natural reaction of moving closer to the truth."

—PEMA CHÖDRÖN

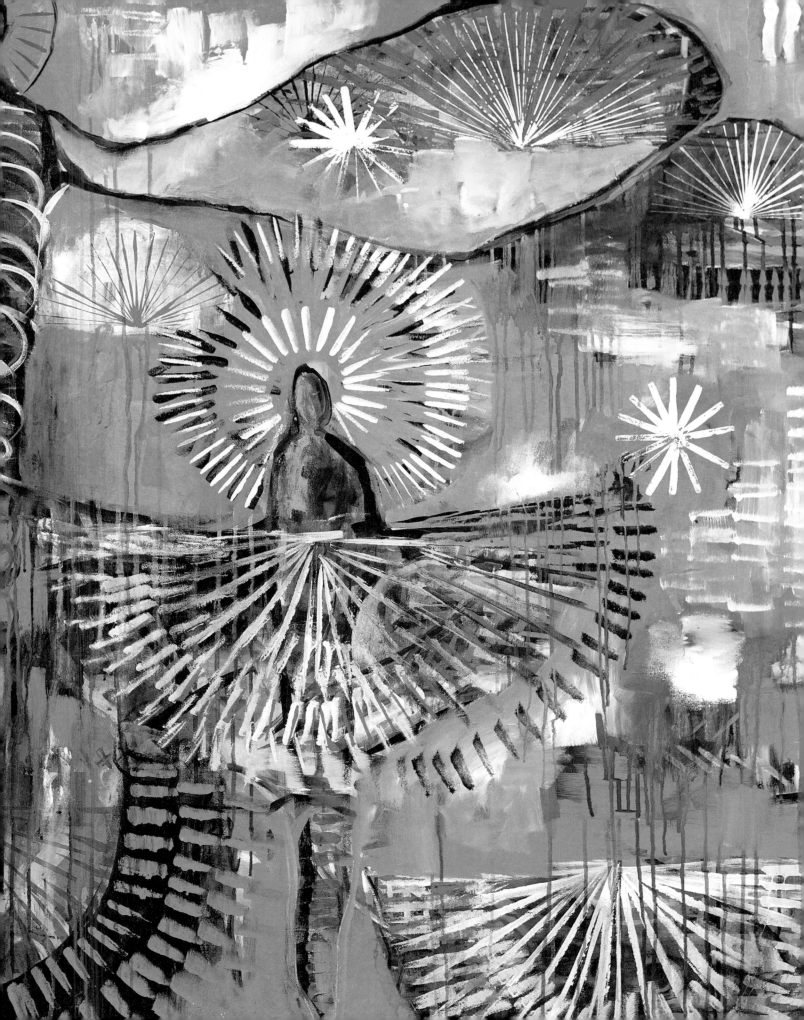

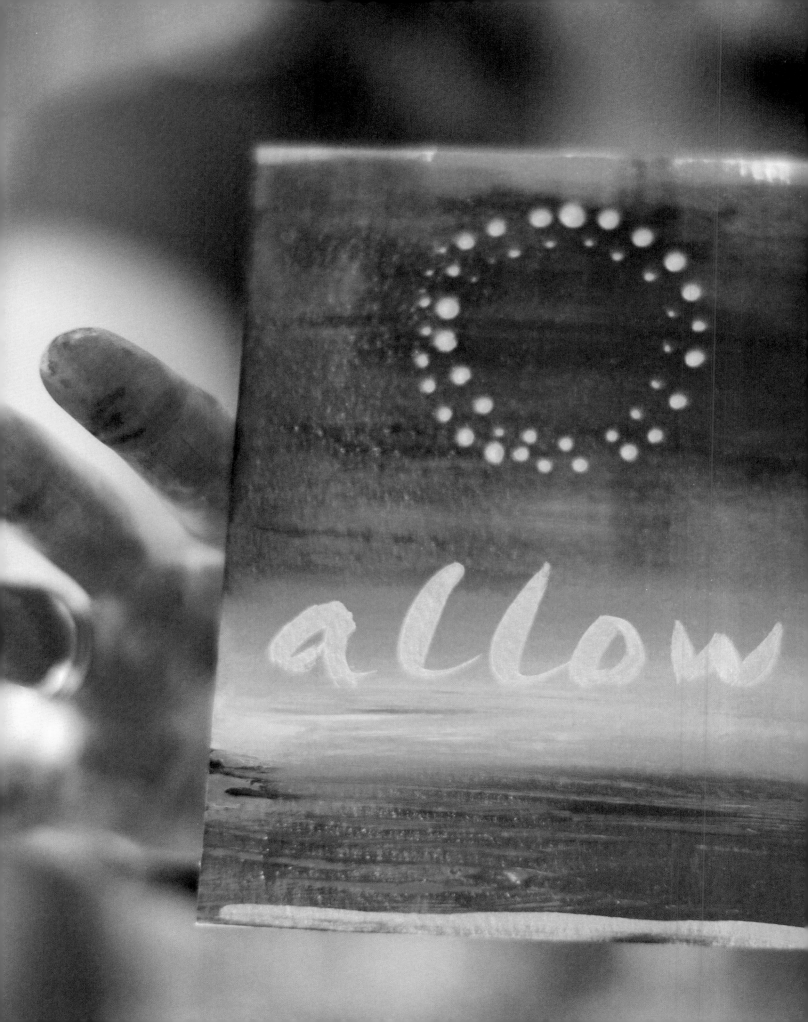

TRUSTING + LETTING GO

TRUSTING THE PROCESS

As you might imagine, being able to trust both the process and yourself are vitally important when it comes to truly embracing the mystery.

You have to trust the seemingly lofty ideas that there are no mistakes and that everything is happening as it is supposed to be happening. Whew, this is not always easy! What about those times you feel like throwing your painting across the room, or breaking out the gesso and whitewashing your canvas?

Witness the frustration. Feel it fully and remember that these moments are actually a crucial part of your creative process. Hitting these walls simply signifies that you're out on a risk-taking edge, and these edges are often not very comfortable!

However, they are often exactly where you experience your greatest break-throughs. Trust the process and keep moving forward. Why? Finding your way through these challenges often yields the greatest lessons.

Yep, just like in life.

"I used to believe I needed to paint something that looked like something. I used to believe I wasn't good enough to be a real artist. I used to believe something was missing. Now I know that the only thing missing was self belief and the courage to take the leap."

—FIONA LOWE (BLOOM TRUE STUDENT)

TRUSTING YOURSELF

If you're feeling a little shaky about trusting yourself in this process, this is a fabulous opportunity to *fake it 'til you make it*.

You see, painting is not a dangerous pursuit. Nobody is going to get hurt if your yellow ends up clashing with your purple. In fact, all that will really happen is that you will learn a little more about yellow and purple.

This painting process is very forgiving: You can cover up, change direction, and try something else at any given time. So why not be bold and pretend you know exactly what you are doing? You truly have nothing to lose, and you just might surprise yourself along the way.

To paint without a plan, you need to trust deeply and know that you are safe in the unknowing.

"I've been absolutely terrified every moment of my life—and I've never let it keep me from doing a single thing I wanted to do."

—GEORGIA O'KEEFFE

LETTING GO

Every day we have the opportunity to let go of the things that no longer serve our highest good. Whether it's unrealistic expectations, regret, unhealthy relationships, or all those extra clothes in our closet, opportunities for releasing abound.

There is a tender line, however, between releasing and holding on, because let's be honest, it's not *all* about letting go. In fact, there's a whole lot of holding on that must happen in order to move through life in a way that is grounded, focused, and forward moving.

The same is true when it comes to your painting. Knowing when to let go and when to hold on is a delicate art in and of itself, and one that takes practice to really understand.

Both in life and on your canvas, it's important to remember that every time you let go of something that is no longer working, you make space for something else to take its place. If you're feeling unenthusiastic about a part of your painting, remember you have the ability to let go and make space for something you actually love.

The clearer you become on what is holding you back and what is moving you forward, the easier it is to loosen your grip and open yourself up to new possibilities.

This process of letting go is a lifelong journey of shedding and renewal, and painting gives you a wonderful opportunity to practice. Let go in baby steps—even having the awareness that you are *ready* to release something is a huge step.

"sometimes letting things go is an act of far greater power than defending or hanging on."

—ECKHART TOLLE

"After the loss of my mother, my paintings changed to hold my grief, and celebrate her life and our love. Through painting I feel I am transforming emotions that are without words. When I give myself time to create I often experience the gift of self healing."

—DENISE DAFFARA (BLOOM TRUE STUDENT)

PAINTING PRACTICE

The nature of painting in layers insists that you let go of something every time you add something else in. If you're are not willing to let go, you create blocks in your natural flow by stepping in the way of spontaneity, new ideas, greater depth, and unexpected twists and turns.

If you *love* something, then by all means keep it, nurture it, and work with it. If you are undecided or not excited, then consider letting it go to make space for something you truly love.

The next two exercises offer ample opportunities to embrace the mystery, let go of planning, trust your gut, and play. Each exercise requires you to respond intuitively to each unfolding layer of paint, while making moment-to-moment decisions as you go.

Staying open and present, and being willing to change directions quickly, are essential to keeping your paintings moving forward.

Much like life off the canvas, the willingness to take each layer as it comes and work with what's working hold the keys to freedom in these exercises.

You can work with these exercises in a step-by-step fashion, or allow the concepts to show up spontaneously in your next painting session. Most importantly, have fun, enjoy the journey, and remember there are no mistakes!

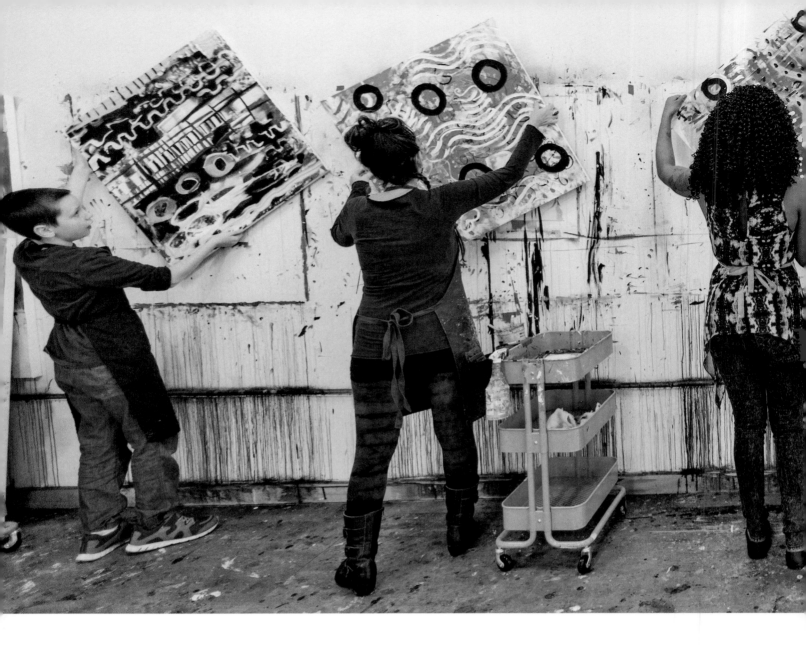

THE **NINETY DEGREE** EXERCISE

Have you ever stepped up to a canvas with an idea you really want to explore? Maybe you discovered a brilliant image of a tree as you were Gathering Seeds of Inspiration and now you want to incorporate that tree in your painting? Great!

This painting process invites and provides space for all your wonderful ideas, right alongside all your spontaneous impulses. There are no rules, and nothing is off limits. In fact, the more you do what feels interesting and good to you, the more your paintings will reflect your own personal style.

But here's the catch. To really stay connected to this process, you'll need to remain flexible and open to change. The moment you "lock down" and force specific outcomes is the moment you close the door on any other possibility.

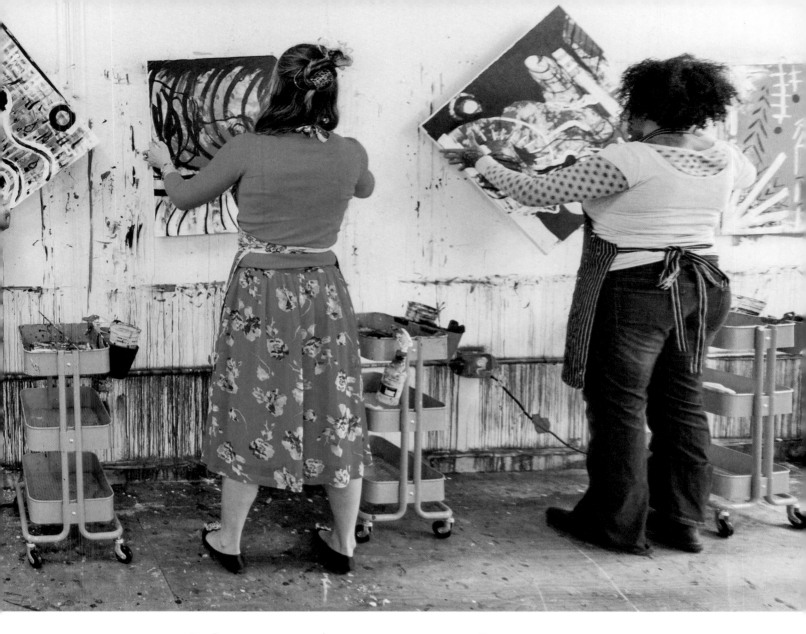

"The secret of change is to focus all of your energy, not on fighting the old, but on building the new." —DAN MILLMAN

For example, if you feel inspired to add that tree to your painting, go for it. Add the tree and see how it goes. Be open to the image staying, morphing, partially going away, disappearing entirely, showing up somewhere else on the canvas, repeating, or getting turned upside down An upside-down tree might be even more interesting than a right-side-up tree!

When you paint with presence and openness to change, so many interesting things can happen—things you never before could have imagined. If you force your ideas to happen in one specific way, you close the door on other options and quite possibly take the fun out of the deal while you're at it.

By rotating your canvas ninety degrees, this exercise forces you (in a gentle, loving kind of way) to let go and stay open with each ever-changing layer. This exercise will definitely keep you on your toes!

1

2

3

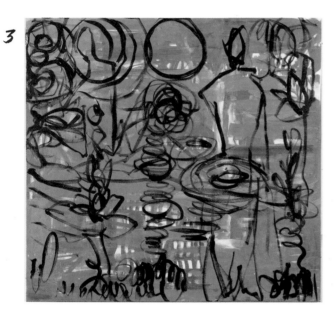

4

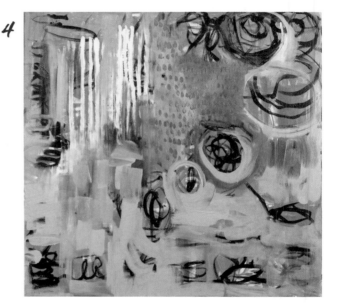

5

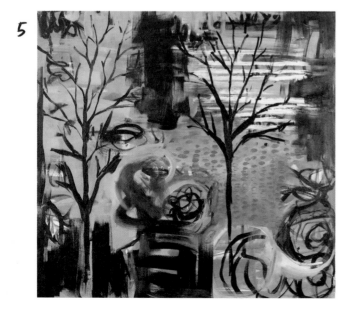

6

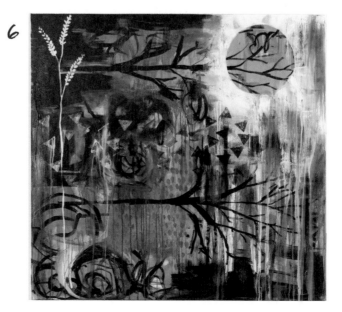

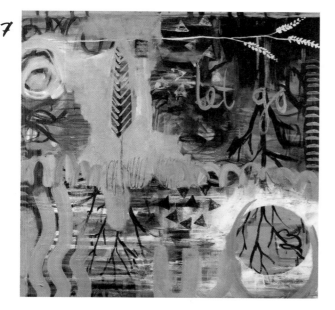

7

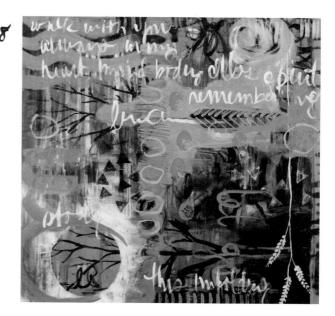

8

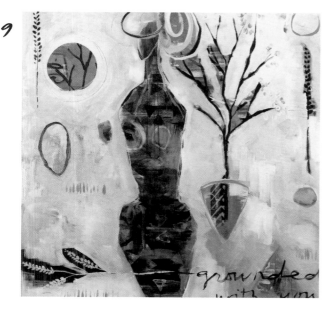

9

HOW IT WORKS

By forcing a new orientation with each layer, we are continually creating new possibilities. Be open to the unexpected each time you turn your painting, and honor the intellect of your body, mind, and spirit along the way.

1. Start with a layer of free-flowing marks to activate all of your canvases. Remember, you don't need to have a plan. In fact, letting go of your need to know where this is all going is what this exercise is all about.

2. After your first layer is dry, return to your original canvas and turn it ninety degrees to the right. Step back and notice if you feel called to do anything specific in this next layer. If nothing is jumping out at you, no problem. Simply add more spontaneous marks and color, and let this layer dry.

3. With each new layer, turn your canvas another ninety degrees to the right until you have painted in each orientation. Continue to step back between layers, soften your need to know anything, but be open to what might feel interesting. Perhaps you'll start to see an image that wants to come to life, or an abstract form that you're drawn to explore.

MATERIALS

- Surface: You are welcome to work on any kind of surface for this exercise. Working on a canvas hanging on the wall or on an easel will allow you to turn your canvas easily and step back to gain new perspective. It will help to work on 2 to 3 different paintings to allow for drying time between each layer.

- Acrylic paint

- Palette

- Brushes

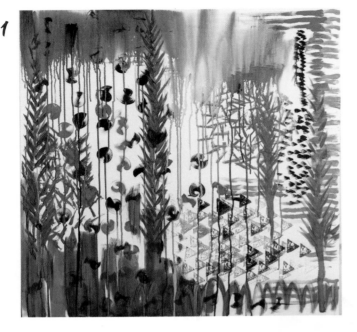

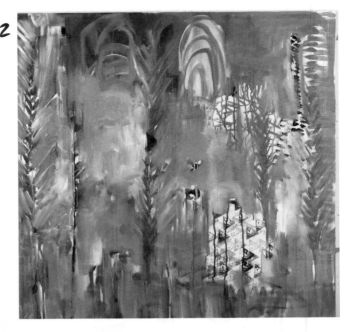

THE **EIGHTY PERCENT** EXERCISE

The Eighty Percent Exercise is all about letting go, simplifying, and making space for new things to happen on your canvas. In each layer, you'll be asked to cover over eighty percent of what is already there. Letting go in such a BIG way makes space for new opportunities, while creating cohesion and forward movement in your paintings.

As always, I hope the practice of letting go on your canvas strengthens your ability to let go in life. Here we go!

Please use the same materials you used for the Ninety Degree Exercise. You can start on fresh canvases or continue on paintings that are already in progress. You'll need more than one canvas in order to allow for drying time between each layer.

Please note, this exercise can be especially helpful if you are feeling stuck with a painting, and you're willing to make big changes to breathe new energy into it.

If you are working on a fresh canvases, paint your first layers in any way you choose. Remember, you are simply activating your canvases with these first marks, so have fun and don't think too hard. Once your first layers are dry, it's time to do some serious letting go by covering over eighty percent of your first layer.

How do know what to cover up, and how do you go about doing this?

There is no "right" way to go about this. Notice if there are parts of your painting you really love. If so, there is no reason to cover these over. Loosen your grip as much as possible, and remember it's only paint!

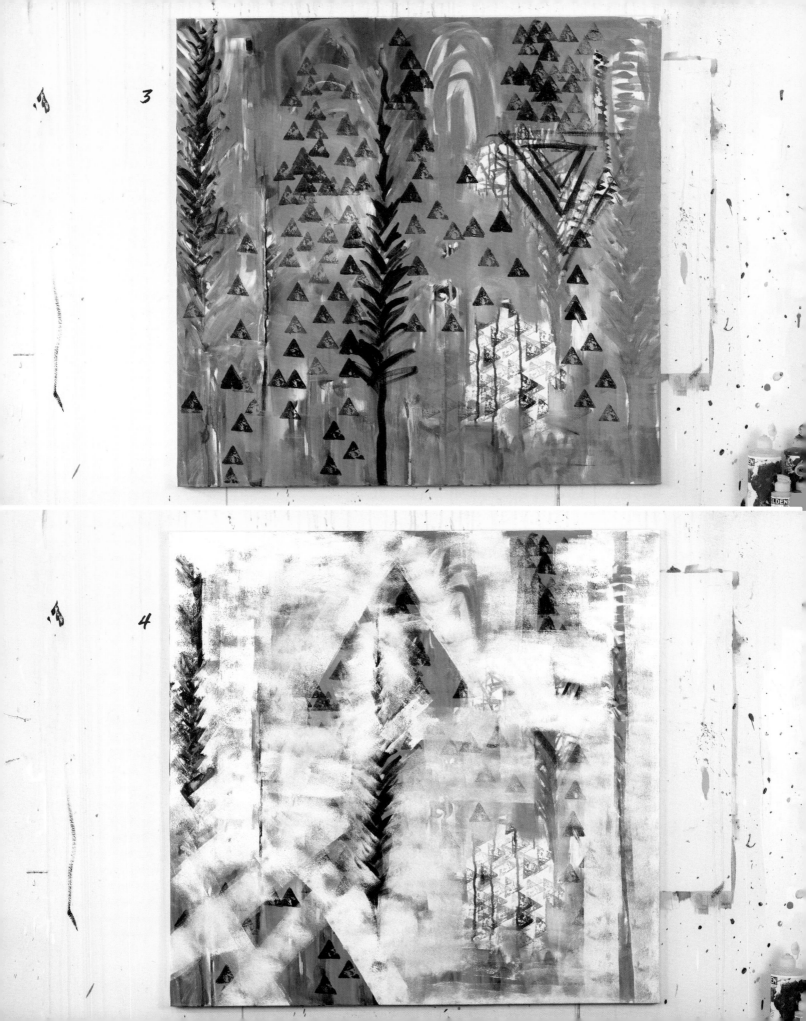

5

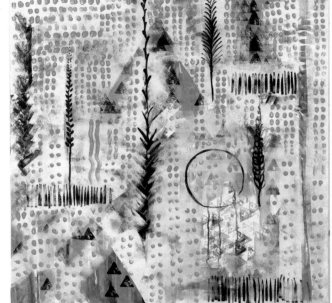

6

Another thing to consider in this exercise is color. Limiting your palette to one or two colors can be a great way to simplify and create cohesion.

For example, if you have an active layer full of rainbow colors and different kinds of marks, imagine what would happen if you covered over eighty percent of that with one single color? Immediately, your painting will feel calmer and more unified.

By calming down the painting, you also create space (almost like a blank canvas) to bring more marks and action back into the painting. By moving back and forth between activating and calming down each new layer, you'll inevitably create depth in your work. Think of it as a conversation between letting go and adding in—back and forth, back and forth.

If you're wondering if you're wasting paint by doing so much covering up, remember every layer is an important part of the story of the painting. Rich, interesting paintings don't often come together in just a few layers. They happen when you are willing to let go and build the story, layer by mysterious layer.

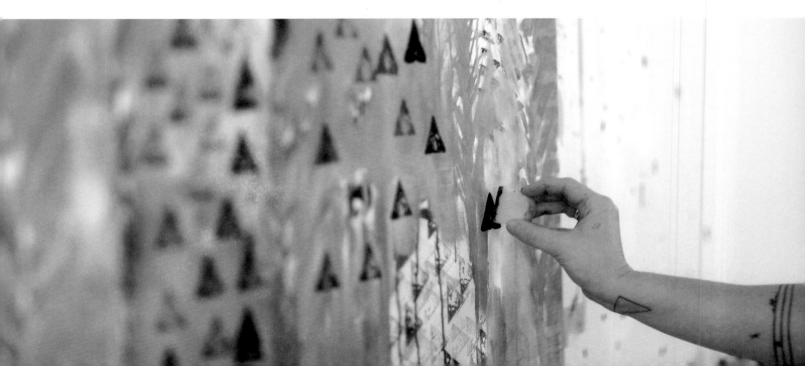

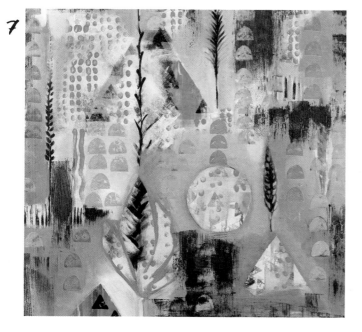

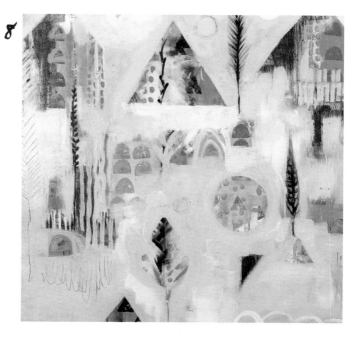

TIPS

The way you add paint to cover over is totally up to you. If you are feeling stuck, here are some suggestions to explore:

— Hold a brush loosely in your hand and "scrub" a new layer of paint on by moving your brush and paint in many different directions as you go. Think of dancing the paint around your canvas.

— Use bubble wrap, potatoes, or any other inspiring object to make stamps across your canvas. Explore repeating patterns with your stamps and random mark-making.

— Add an image or repeating images.

— Explore abstract shapes.

— Use a roller.

— Paint with your fingers.

— Add drips with your water bottle.

"Covering more than uncovering introduces us to the mysterious, yet exposes us to the hidden, to engage and invigorate us." —ORLY AVINERI

MANDALA MEDITATION

Mandalas have been used across many cultures as a way to chart the cosmos (inner and outer), focus attention, meditate, and create sacred space.

The word *mandala* means circle in Sanskrit, and many mandalas are circular in form. Although there are certainly no formulas, most mandalas include a central point with an array of shapes, symbols, and images radiating outward from this point.

I enjoy working with spiritual illustrations as a way to slow down, focus my awareness, and practice mindfulness. Creating mandalas can serve as a moving meditation in this way. They can also provide the perfect amount of structure to explore and discover new symbols, marks, lines, and shapes.

"Open your eyes to the beauty around you. Open your mind to the wonders of life. Open your heart to those who love you. And always be true to yourself." —MAYA ANGELOU

MATERIALS

This exercise can be done using traditional art supplies or found objects. Here are a few suggestions:

- Cardstock or sketchbook paper work well. If you are using paint, you might want a heavier paper, such as 140 lb watercolor paper. Try working on different colored paper, too.

- Markers, pens, pencils, pastels, and paint are all great mediums to explore.

- You can also make mandalas out of natural items, such as rocks, flowers, branches, and sand. (What kind of mandalas can you make from items in your house?)

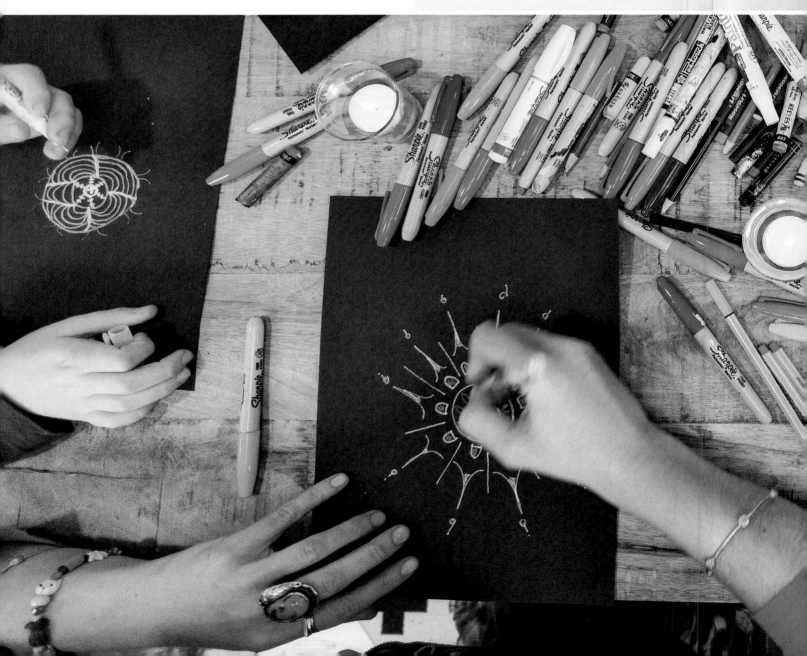

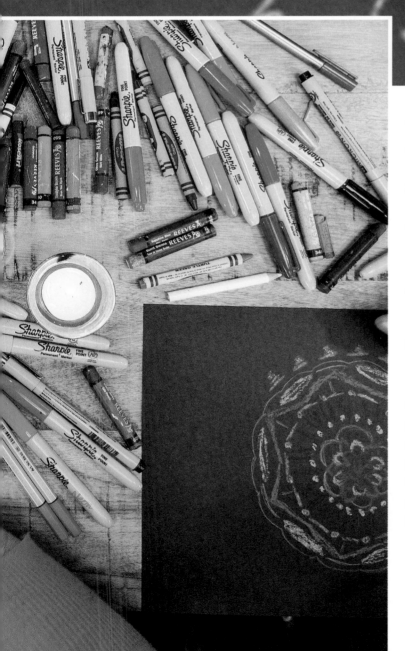

MAKING YOUR MANDALA

1. Before you begin, consider lighting a candle and taking a few deep breaths to gather and focus your attention inward.

2. With your chosen materials, start by making one small dot or shape in the middle of your mandala.

3. From that center point, create the next ring out by using a different kind of mark, shape, or material. Circles, dashes, words, stars, diamonds, lines, and dots are great shapes to include. What other shapes are showing up in your mandala?

4. Continue adding rings to your mandala until your mandala feels complete. Allow each ring to be a unique expression of the present moment.

5. You are welcome to go back inside your mandala to add or refine areas at any time.

Creating mandalas in this way can be a beautiful and meditative practice, one that quiets the mind, celebrates intuition, and grounds you in the present moment. Let go of any preconceived ideas about what your mandala is supposed to look like, and simply allow your intuition and curiosity to lead the way.

COLLABORATIVE PAINTING

If you've ever felt isolated or stuck in your creative process, I highly recommend exploring collaboration as a way to break up the monotony, welcome in new ideas, and—you guessed it—embrace the mystery. Working collaboratively opens the door for enormous opportunities to let go, trust, and grow. It's also my idea of a really good time.

Can you imagine how much trust it takes to let somebody else paint on your canvas, and how much you might learn if you're willing to take this risk?

Inviting other people into your creative process opens up new doors of possibility, while infusing the work with a fresh burst of unique creative energy. At the very least, it's sure to be a bonding experience between you and your collaborators!

There are many ways to work toegther, and I'm happy to share a few of my favorites with you here. At the core of most of my collaborations is an understanding that everything is fair game. This means each person has the power to change, cover up, add to, or otherwise alter the whole painting in any way they see fit, unless or until the other person requests an area to remain off limits. This simple formula creates the freedom and space necessary for empowered collaboration.

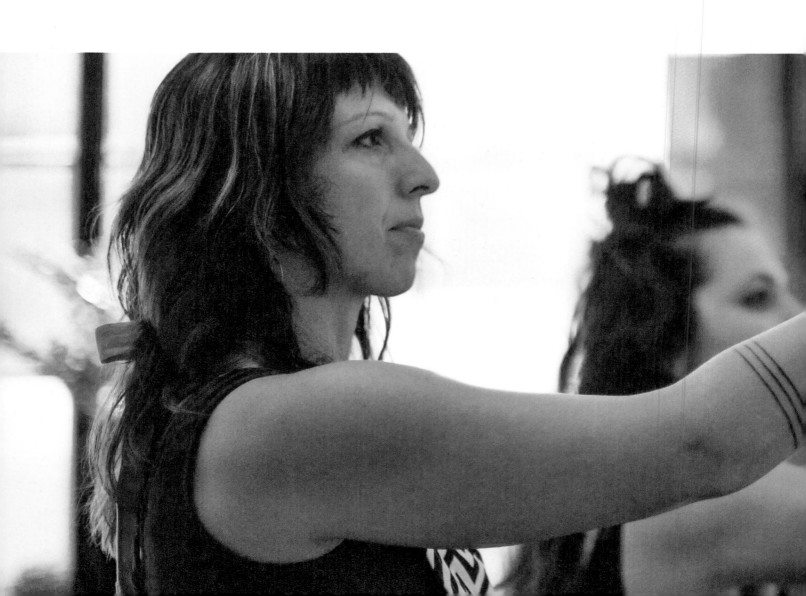

I encourage you to release any personal agendas around how the process is going to unfold. The beauty and power of working collaboratively comes from putting your ego aside, paying close attention to what your collaborators are bringing to the table, and being able to consciously work through any conflict that might arise.

— **Consider working with the phrase, "Yes, and . . . "** as a way to stay rooted in possibility as you embark on your collaborations.

— **Work together on one surface:** Whether you're painting on a canvas or drawing on paper, creating simultaneously on one surface is a great way to play off each other's choices in a really immediate way. Use pens, paints, markers, or any other tools you have on hand. Let go of the need to plan or plot, and find inspiration from each other's ideas as you create simultaneously.

— **Pass your paintings or drawings back and forth:** Another way to explore collaboration is to work on individual creations, passing them back and forth as you go. You can work next to each other, or work back to back if you want to embrace the element of surprise. Again, there is no formula except to work with what comes your way and don't hold back. Bold moves make for bold collaborations!

— **Work with a larger group:** Collaboration can get even more interesting when you invite more people to the table. For example, start with six people and six canvases (or surfaces of your choice). Spread the canvases out and move around the room adding layers and marks as you go and playing off each other's ideas. It can be helpful to set a timer to remind you to move, or just go with what feels right and have fun!

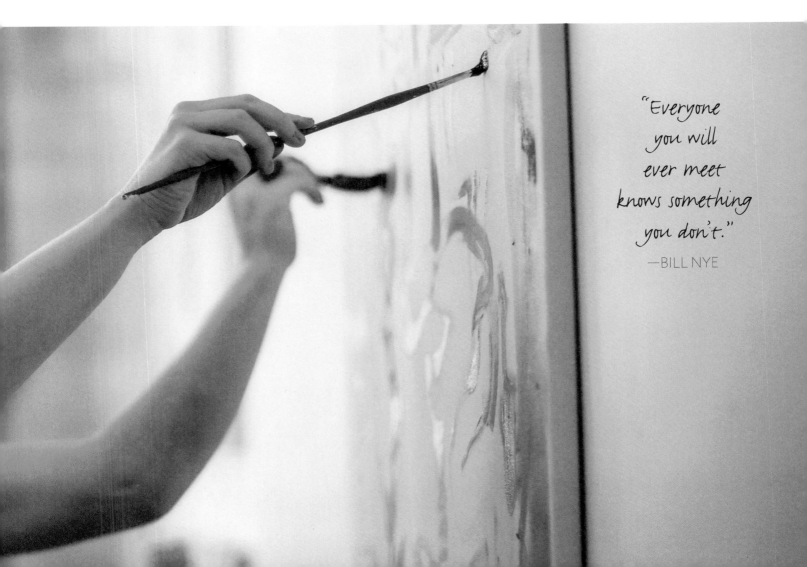

"Everyone
you will
ever meet
knows something
you don't."
—BILL NYE

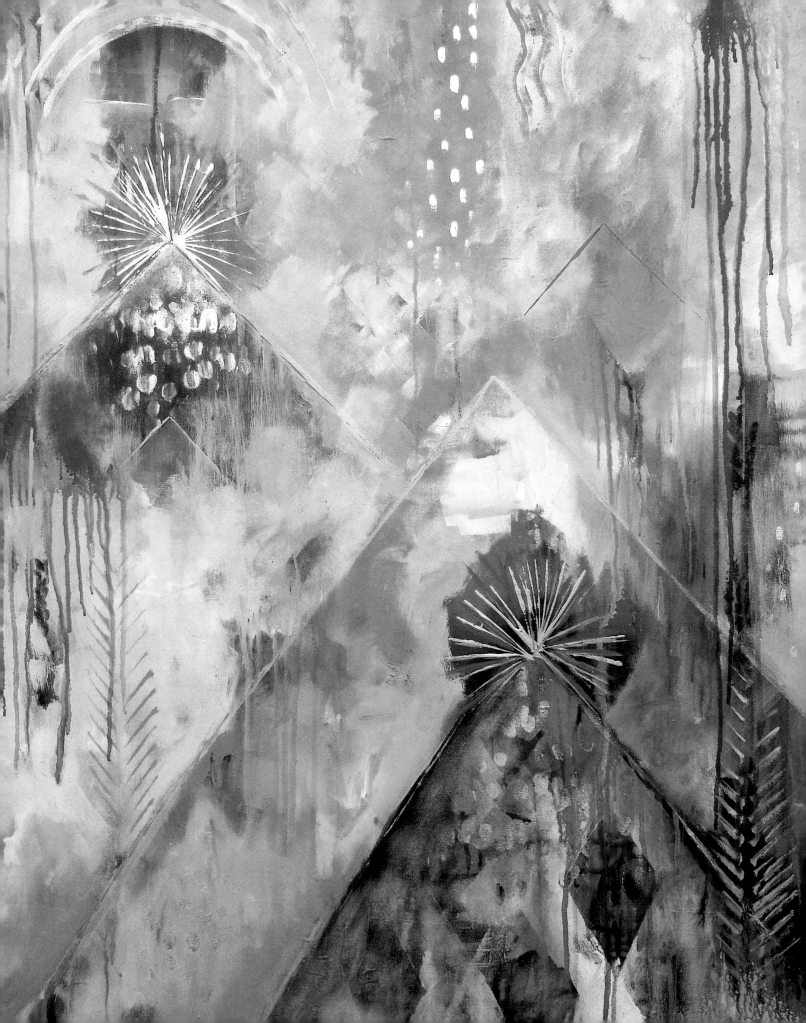

Conclusion

I wrote this book in the year following my beloved mama's unexpected seven-week departure from this earthly realm. Along with my sister and brother-in-law, I was given the incredible (and heartbreaking) role of midwifing her to the other side—an honor I am forever grateful for.

For anyone who has walked the path of grief, you know how profound and enlightening this journey can be. As you might imagine, writing a book about "personal transformation" during this particularly trying time was not always easy, but it was undeniably poignant and deeply personal.

It's clear to me now that my greatest loss and pain simultaneously granted me access to the most powerful lessons in love and life imaginable, and I know these lessons will continue to reveal themselves for the rest of my life.

Thankfully, I've had the potent vehicles of writing, painting, and movement to aid in tangibly processing the vast spectrum of the raw emotions and insights that surfaced over the past year, while solidifying my belief in the power of art medicine.

While it's difficult to sum up the immense impact the loss of my mom has had on my life, I would love to acknowledge all the wonderful ways Carol's life inspired me and influenced the words within these pages.

As I mentioned in the Body section, my mom's pioneering work to foster the body-mind-spirit connection with children at the YMCA touched thousands of lives and left behind a lasting legacy of positive change. She wholeheartedly believed in every human's potential for greatness, and she was passionate about empowering and instilling a sense of confidence and self-love through creative movement and community building.

If Carol was in the room, you felt seen, heard, and loved—and there's a good chance you were dancing and singing a silly song, too.

My mom was not a so-called "artist." She left that role to her husband, sister, and children. But she had a tremendous ability to think outside the box and approach every aspect of life with a sense of playful creativity. For every challenge, she had an innovative, can-do solution, while always pointing out the opportunities for growth along the way—especially when it came to the hard stuff.

When my passions for painting, movement, personal growth, and community started to weave their way together in my workshops, it immediately felt like a continuation and honoring of the work my mom had dedicated her entire life to. While the vehicles for transformation differ, the heart of our message is certainly the same.

Whether you're utilizing song, dance, paint, community service, or any other vehicle to explore the beckoning whispers of your soul, your own creative revolution is patiently waiting to show you just how extraordinary you truly are.

I assure you, Carol would agree.

About the Author

FLORA BOWLEY is an artist, author, and gentle guide whose soulful approach to the creative process has transformed thousands of lives. Blending over twenty years of professional painting experience with her background as a yoga instructor, healer, and lifelong truth seeker, Flora's intimate in-person workshops and popular online courses have empowered a global network of brave painters, while creating a new holistic movement in the intuitive art world.

Her first book, *Brave Intuitive Painting* (Quarry Books, 2012), provides a luminous documentation of this innovative approach, while *Creative Revolution* dives even deeper into the transformational potential inherent in this way of creating. Flora's own vibrant collection of paintings can be found in galleries, shops, and printed on unique products around the world.

Flora believes that creative expression is waiting to unfold within every person who is brave enough to trust, let go, and explore, and it is through this kind of heartfelt expression that truths are revealed, lives transform, and new worlds are born.

Flora lives with her partner, Jonathan, his son, Miles, and their dog, Pearl, in Portland, Oregon.

For more information, please visit www.florabowley.com.

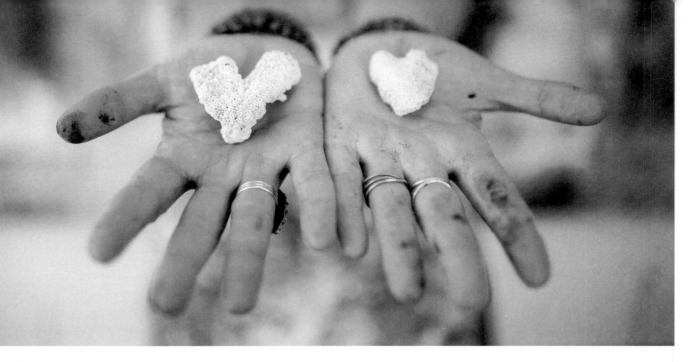

Acknowledgments

Over the past six years, I've had the honor of witnessing thousands of people transform their lives through the creative process. This book was born from my desire to share a glimpse of this magic with you, while paying respect to all the courageous people who continually step up to the blank canvas without a plan—trusting, letting go, listening in, and moving closer and closer to their soul's true calling.

The book you are holding in your hands is for them—and for you.

Creative Revolution was also brought to life through the immense support of my biggest cheerleaders and spirit guides, many of whom were kind enough to be featured "models" in these pages.

Thank you Jonathan Wood, Cvita Mamic, Erin Bowley, Jeremy Szopinski, Mom, Dad, Tara Morris, Pixie Lighthorse, Kelly Rae Roberts, Anahata Katkin, and Pearl Dog for all wonderful ways you love and support me.

And to my amazing friends and models: Ann Hyams, Anouk Froidevaux, Diane Sherman, Erin Martin, Jill Golden, Holly Hamilton, Katie Shook, Latisha Strickland, Lisa Mae Osborn, Meredith Wood, Miles Wood, Nafasariah, Niema Lightseed, Nikki Cade, Patrick Michael, Samantha Backer, Shannon Sims and Wayne Singer. Thank you for playing along and generously gracing these pages with your beautiful spirits.

To my dream team: Anya Hankin, Phoenix Anthony, Lynzee Lynx, and MaryBeth Bonfiglio. We did it, ladies! I love you all.

To my dear friend and phenomenal photographer, Zipporah Lomax. I'm sending you a lifetime of thanks for all the symbiotic ways we collaborate and support each other. Your stunning photography and savvy way with light truly make the pages of these pages come alive.

And to Mary Ann Hall and the whole Quarry Books crew. Thank you for trusting me and gently coaxing this idea into reality. I am forever grateful.

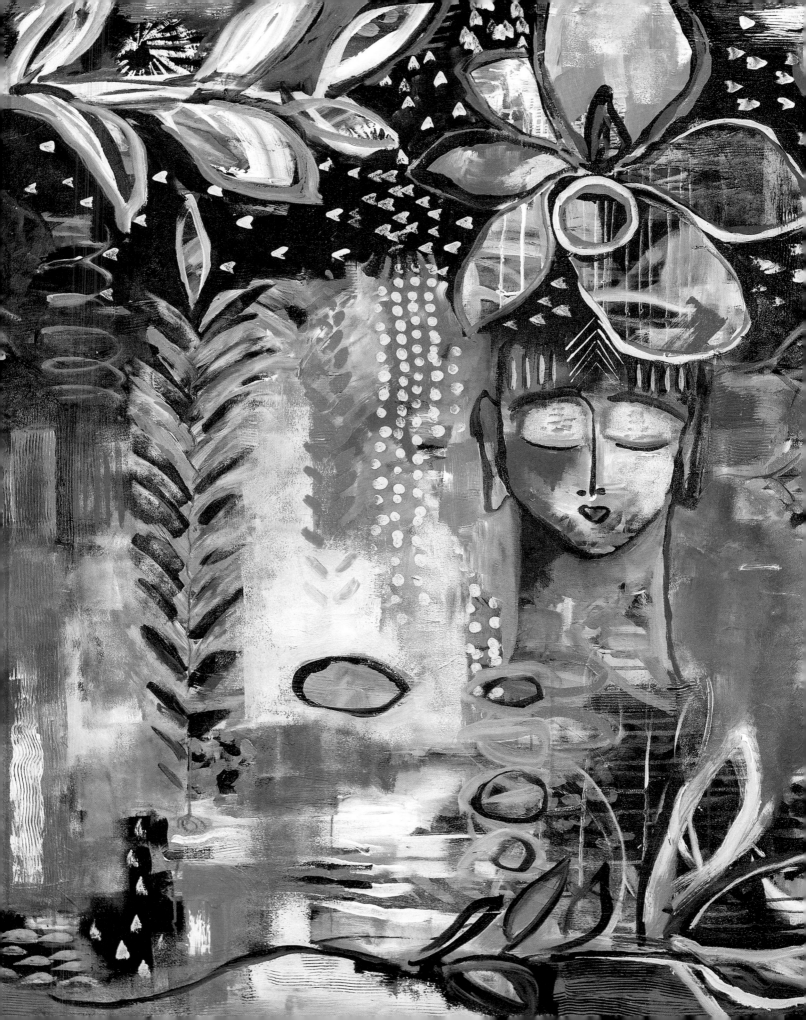

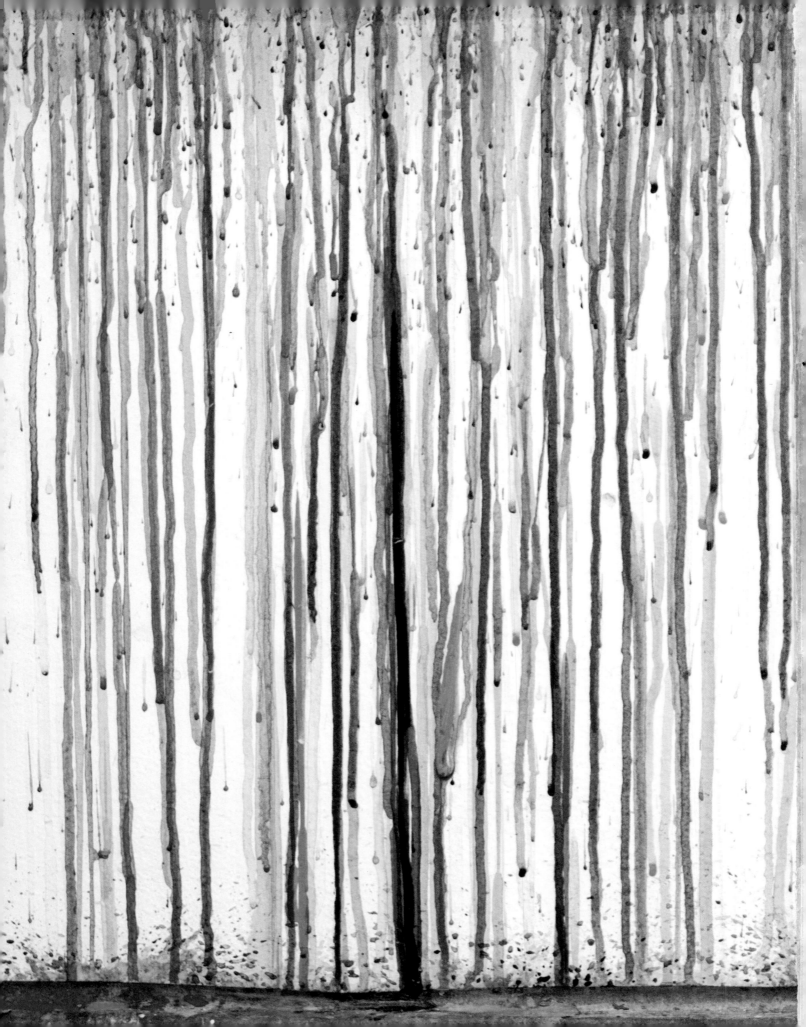